T0102034

LITTLE BOOK OF

Alexander
McQUEEN

This book is a publication of Welbeck Non-Fiction Limited, part of Welbeck Publishing Group Limited and has not been licensed, approved, sponsored, or endorsed by any person or entity. Any trademark, company name, brand name, registered name and logo are the property of their respected owners and used in this book for reference and review purpose only.

Published in 2023 by Welbeck
An imprint of Welbeck Non-Fiction Limited
part of Welbeck Publishing Group
Offices in: London – 20 Mortimer Street, London W1T 3JW &
Sydney – 205 Commonwealth Street, Surry Hills 2010
www.welbeckpublishing.com

Text © Karen Homer 2023

Picture Researchers: Nini Barbakadze and Josephine Giachero

All rights reserved. This book is sold subject to the condition that it may not be reproduced, stored in a retrieval system or transmitted in any form or by any means, electronic, mechanical, photocopying, recording or otherwise without the publisher's prior consent.

A CIP catalogue for this book is available from the British Library.

ISBN 978-1-84796-100-6

Printed in China

10 9 8 7 6 5 4 3 2

MIX
Paper | Supporting
responsible forestry
FSC® C020056

LITTLE BOOK OF

Alexander
McQUEEN

The story of the iconic fashion designer

KAREN HOMER

WELBECK

CONTENTS

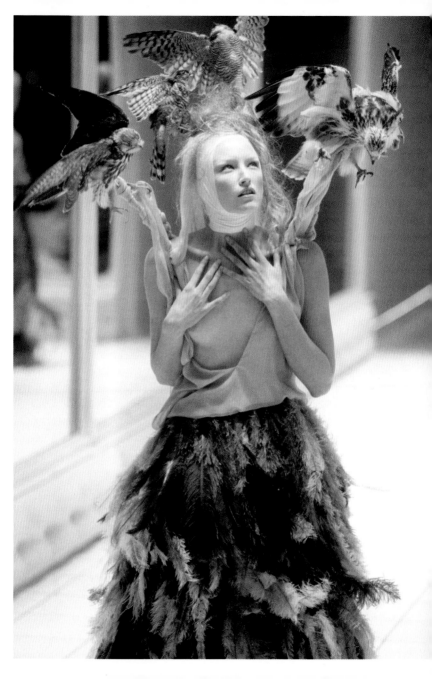

INTRODUCTION

"The world needs fantasy, not reality.
We have enough reality today."
ALEXANDER McQUEEN

Lee Alexander McQueen was more than just a fashion designer; he was an artist who truly deserved to be called a genius. His outlandish and sometime shocking creations, "bad-boy" behaviour outside the studio and theatrical catwalk shows distracted from the fact that he was, above all, a superb craftsman.

Born in London's East End, the son of a taxi driver, McQueen overcame all the odds to reach the highest echelons of the fashion world. He left school at just 16 to take up a tailoring apprenticeship in London's famous Savile Row. This rigorous, classical training, combined with a stint working for the theatrical costumiers Angels and Bermans, meant that when he graduated from Central Saint Martins, his singular aesthetic was already well formed. His degree show collection was famously bought by Isabella Blow, who became his patron, muse and friend.

OPPOSITE Alexander McQueen at his theatrical best for his S/S 2001 show Voss. The themes were nature and madness, with the models trapped in a set resembling a padded cell. Here, model Karen Elson is surrounded by stuffed birds and her skirt is made from feathers. Her head is bandaged and her clothes seem to be half torn off her.

McQueen was a true autodidact, inspired by history and art, genealogy and folklore. Every one of his collections was meticulously researched, and his inspirations ranged from the macabre murders of Jack the Ripper to the legend of Plato's utopian city of Atlantis. Cinema, especially thrillers and gothic film noir, had a huge influence on his designs, with collections sparked by the work of directors including Alfred Hitchcock and Tim Burton.

From the very beginning of his career, he changed the fashion landscape, most notably with his provocatively low-cut "bumster" trousers, which caused a scandalous reaction despite the style quickly filtering down to the high street. This was an early example of how McQueen's intentions were often misinterpreted. The butt-crack-revealing style was designed not just to shock but to reveal what McQueen considered the most erotic part of the body: the base of the spine.

Particularly during the early years of his career, McQueen fought the accusation that he hated women. As he told the writer Dana Thomas:

"Some people say I'm a misogynist. But it's not true. Opposite. I'm trying to promote women as the leaders. I saw how hard it was for my mum to take care of us, and I try to promote the respect and strength of women."

McQueen was a Londoner through and through and, after an uneasy few years in Paris heading up the luxury French couture label Givenchy, he returned home. He spent the next decade honing his craft, epitomized by his vision of a bold and sexual "warrior woman".

McQueen's turbulent personal life was bound up in the inevitable excesses of partying, drugs and celebrity. He was troubled both within himself and about the state of the fashion world, with its demands of unrealistic perfection. The suicide of his mentor Isabella Blow in 2007 was a shock and, though he seemed to find a new equilibrium, the death in 2010 of his beloved mother,

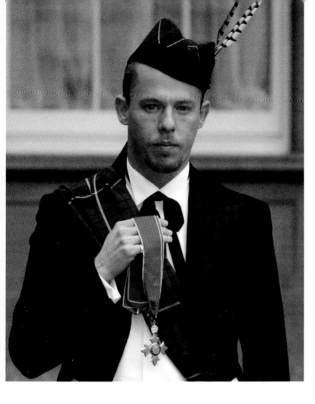

LEFT Alexander McQueen, wearing the MacQueen clan tartan, was awarded the CBE by Queen Elizabeth II in 2003.

Joyce, proved too much. Driven out of his mind by grief, he took his own life barely a week later, on 11 February 2010.

Since his death, the McQueen label has been headed up by Sarah Burton, the light to McQueen's shade, who had been his trusted deputy for over a decade.

The 2011 *Savage Beauty* retrospective of McQueen's work, at the Metropolitan Museum of Art, showed the world the immensity of his talent, both in the sculptural quality of his designs and in the catwalk moments that reached the level of performance art. McQueen also left the legacy of the Sarabande Foundation, a charitable organization dedicated to the support of young, creative talents.

EARLY YEARS

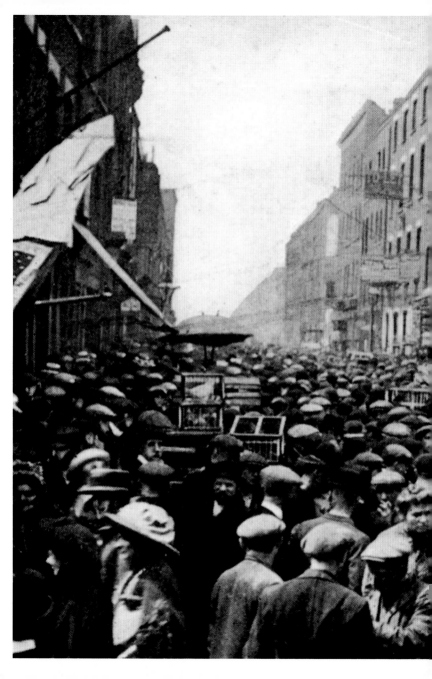

A COCKNEY
BORN AND BRED

Lee Alexander McQueen was born in Lewisham in London on 17 March 1969. Living just about close enough to be able to hear the sound of Bow Bells ringing, McQueen built his image on his roots as a working-class Cockney and a "bad boy done good".

He was the youngest of six children, his father a taxi driver and his mother a social science teacher, making his rise to become one of the most prominent and successful fashion designers of his generation even more extraordinary.

From a young age, McQueen showed a keen interest in clothes, making dresses for his three sisters. At primary school he announced he wanted to be a fashion designer. Realizing he was gay at the age of six, McQueen was bullied and harassed as well as suffering sexual abuse at the hands of his sister Janet's violent husband.

In an interview with *The Times* in 2015, Janet said that she believed that McQueen witnessing her being beaten by her abusive husband led him to want to dress women that people would be "afraid of".

OPPOSITE As a proud Cockney, McQueen found inspiration in the history of the East End. Old photographs of the Victorian-era Club Row bird market on Sclater Street held a particular appeal for the designer, who had loved birdwatching as a child and frequently used bird motifs – as well as live and stuffed birds – in his shows.

Describing himself as the "pink sheep" of the family, he came out as homosexual to them aged 18, which triggered a turbulent relationship with his father in particular. The close-knit family did eventually reconcile, and McQueen was especially devoted to his mother, Joyce.

McQueen was very much his own person even as a teenager, often observing others from a distance and happy to spend hours birdwatching from the roof of his tower block, an obsession that heavily influenced his later fashion designs.

He eventually left school aged 16, with one O-Level qualification in art, to take up an apprenticeship at the Savile Row tailor Anderson & Sheppard, where he spent several years learning the intricacies of cutting the perfect suit before moving to the upper-crust establishment Gieves & Hawkes. The rigorous and precise training that McQueen received during this time served the designer well as he moved into couture. Throughout his career, he remained obsessive about achieving a perfect cut. He is quoted by the Victoria and Albert Museum as saying: "Everything I do is based on tailoring."

McQueen went on to explain how he was nevertheless determined to push the boundaries of clothes construction, which he did to remarkable effect: "You've got to know the rules to break them. That's what I'm here for, to demolish the rules but to keep the tradition."

After leaving Savile Row, McQueen worked briefly as a pattern cutter at the costumiers Angels and Bermans, where he worked on stage outfits for productions, including *Les Misérables*. The world of costume, with all its drama and hyperbole, was as important to the designer as his rigid training in tailoring, and here, McQueen found a template for both his love of historical silhouettes and his signature theatrical style.

Finally, McQueen spent some time working for the avant-garde designer Koji Yatsuno in London before joining Romeo

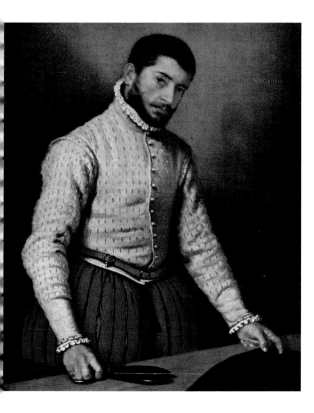

LEFT As a young man, McQueen visited the National Gallery, finding inspiration in paintings which included historical dress. This image of *The Tailor*, painted in 1565 by Giovanni Battista Moroni, is particularly fitting given McQueen's later apprenticeship on Savile Row and lifelong devotion to the art of tailoring.

Gigli as a design assistant in Milan in 1989.

Returning to London, where he admitted to a friend he needed to work to stop his "overdraft building up", McQueen applied to Central Saint Martins to become a pattern-cutting tutor. However, instead of being offered a job, he was encouraged by Bobby Hillson, Head of the MA Fashion Course, along with Jane Rapley, Dean of Fashion and Textiles, to apply for her course. McQueen did so, and became arguably the most memorable and successful of the London fashion college's list of famous alumni.

CENTRAL
SAINT MARTINS

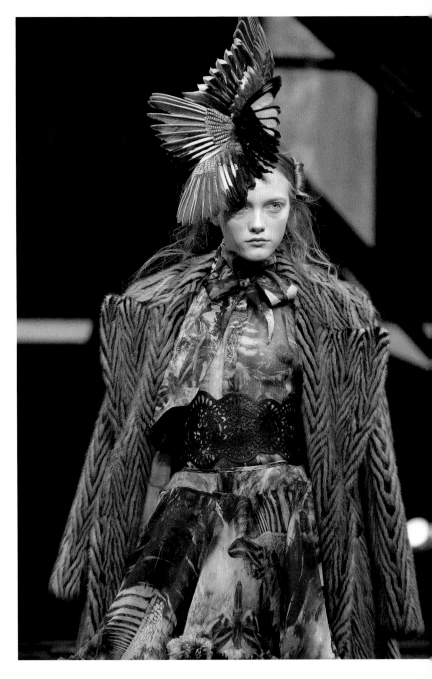

TRAINING A NATURAL GENIUS

When Lee McQueen arrived at Central Saint Martins in 1990 aged 21, he already had more experience than many of his contemporaries.

McQueen's talent was immediately spotted by Louise Wilson, who took over the MA fashion course in 1992. The inspirational professor, who shaped a generation of fashion stars, remembered both McQueen's technical skills and his self-reliance in an interview for New York's Metropolitan Museum of Art in 2011:

> *"An architect doesn't build the house for you; they employ the builders, whereas Lee, in effect, built the house because he cut the patterns and he sewed the jackets. Basically, he didn't need to depend on anybody."*

OPPOSITE McQueen's genius was obvious, even while he was a student. As he matured as a designer his early love of juxtaposing texture and print only grew, along with his preference for animal and bird motifs into his designs, and he created increasingly complex outfits, such as this printed dress teamed with a richly hued fur coat and feather headpiece from his A/W 2006 Widows of Culloden collection.

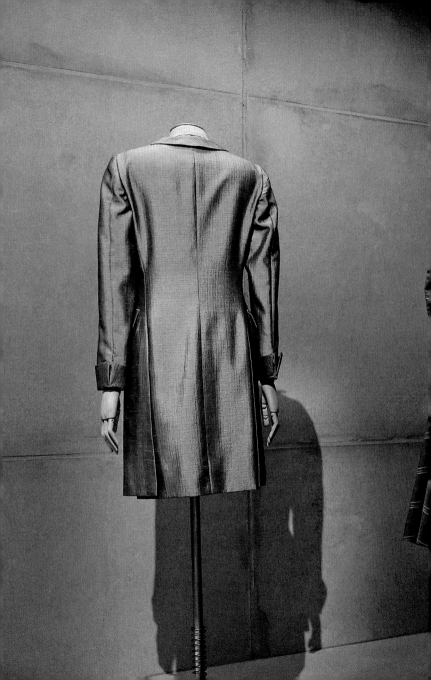

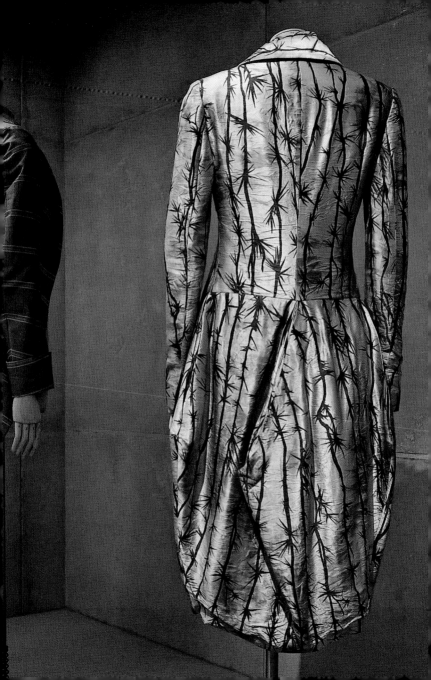

PREVIOUS PAGES
This selection of
jackets from the
2011 *Savage Beauty*
retrospective of
McQueen's work
includes a striking
pink frock coat,
printed with barbed
hawthorns, from
his Jack the Ripper
Stalks His Victims
collection. The
print is by Simon
Ungless and the
coat was rumoured
to be smeared with
bloodstains for
authenticity.

However, McQueen wasn't entirely a loner, forming a close friendship with fellow student Simon Ungless. Their collaboration lasted beyond their graduation. Ungless, a textile designer who now also teaches at the University of San Francisco, played a big part in the formative years of McQueen's career.

McQueen thrived not only on the rich creative atmosphere generated by his fellow students at Saint Martins, but also by taking full advantage of London's abundance of museums and art galleries. He was a regular visitor to the historical archives of the Victoria and Albert Museum, which he said "never fail to intrigue and inspire me".

The designer also drew inspiration from the darkly gothic paintings held at the National Gallery, and cited Paul Delaroche's 1833 picture *The Execution of Lady Jane Grey* as one of his favourites. The striking image of the doomed queen dressed in virginal white and blindfolded is very much in keeping with some of McQueen's later, more controversial creations.

Always with an eye on the new as well as the past, McQueen was equally hyped up by the buzz around the exploding world of Brit Art, especially avant-garde young artists such as Damien Hirst and Tracey Emin. It was his ability to draw inspiration from such wide-ranging sources that gave his fashion design a distinctive edge.

JACK THE RIPPER STALKS HIS VICTIMS (1992)

McQueen's graduate show collection was entitled Jack the Ripper Stalks His Victims and was inspired by the Whitechapel murders of 1888. McQueen's themes often had an autobiographical element: the East End connection is obvious enough, but his fascination with genealogy had revealed that one of his relatives owned an inn that rented a room to a victim

of Jack the Ripper. His tutor Louise Wilson recalled how storytelling was so important to McQueen's collections:

"[Students] had to do something called a marketing report, which was basically setting their collection in context. And even then, Lee's report was on genealogy – Jack the Ripper – and quite in-depth. So it was telling the story of his collection even at that stage. You know, it was really, really personal to him."

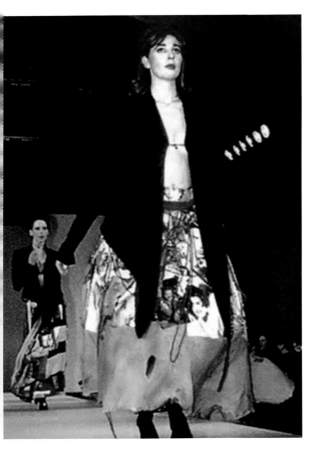

LEFT A rare image from McQueen's graduate fashion show for Central Saint Martin's entitled Jack the Ripper Stalks His Victims. His signature tailoring and favourite Edwardian silhouette are already obvious. The skirt features screen-printed images by his friend and collaborator Simon Ungless.

The collection was remarkably sophisticated for a graduating student. Victorian silhouettes were rendered in a palette of black and burgundy, with bloodlike accents of red peeping from their silk linings as well as lilac, the traditional colour of mourning. Unsurprisingly, tailoring was the focus, exhibiting McQueen's greatest skill to full advantage. For example, a black wool frock coat was customized by reversing the bottom half of the sleeve to reveal the mauve lining.

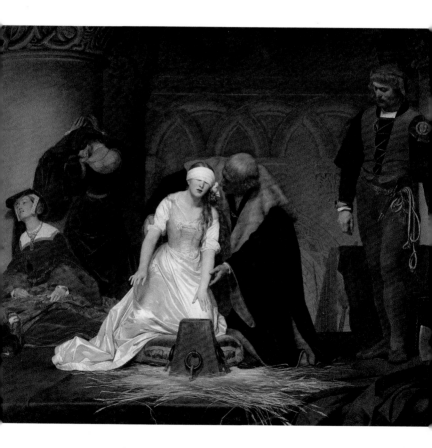

OPPOSITE Historical paintings were a great inspiration to McQueen, and Paul Delaroche's 1833 picture *The Execution of Lady Jane Grey* was one of his favourites. The image of the doomed and helpless queen, dressed in virginal white and blindfolded, clearly influenced McQueen's later work.

In a series of technically accomplished outfits, McQueen offered a gothic twist on Victorian fashions, including butterfly-printed ruffled gowns and, more darkly, a silk satin frock coat printed with barbed hawthorns, the fabric designed by Simon Ungless, and reputedly smeared with bloodstains.

Discussing this iconic coat with photographer Nick Knight in 2015, fashion writer Susannah Frankel describes the way in which McQueen created his early pieces with an oblique brutality that shadowed his work throughout his career:

"He is taking a fabric and attacking it. It is amazing the fabrics early on could take Lee's treatment without falling apart because they were very heavily worked… and very aggressively worked."

McQueen has been quoted as saying: "I find beauty in the grotesque." This propensity to include provocative and shocking elements within his designs is already clear in this first collection. To this end McQueen sewed a lock of his own hair, encapsulated in silk or Perspex, into each and every catwalk garment. The reference was to the Victorian fashion for lovers to gift locks of hair, which they bought from prostitutes rather than cut and ruin their own.

McQueen's graduate collection set the stage not only for a career that pushed the boundaries of what was acceptable in fashion but also for the criticism he would suffer from throughout his life – that he was a misogynist or, even worse, a sadist.

Nevertheless, McQueen's talent was undeniable. Sitting in the audience at his graduate show was the eccentric stylist Isabella Blow, who famously paid £5,000 for the collection. Blow, who would become McQueen's friend, muse and patron, was the first to see clearly the huge potential of the fashion genius that was Alexander McQueen.

EARLY
COLLECTIONS

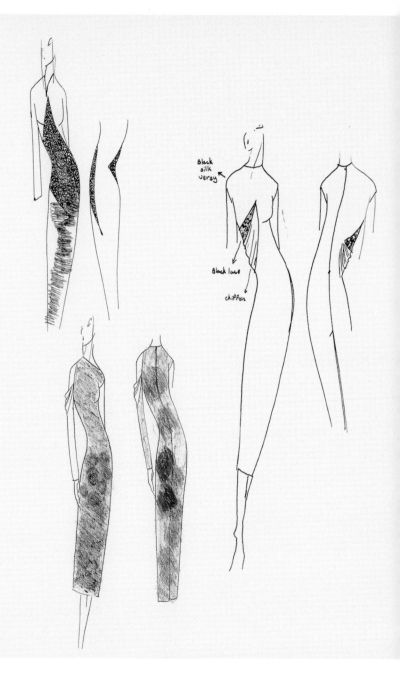

Black
silk
Jersy

Black lace

chiffon

UNAFRAID
TO SHOCK

McQueen was that rare being, a truly individual fashion designer. His strong, and often controversial, vision was obvious even in his earliest collections.

TAXI DRIVER (A/W 1993)

McQueen left Saint Martins and immediately started designing, in the hope that he could make a success of his own label. He was encouraged by Isabella Blow, for whom he also worked as an assistant. The designer later admitted that he was still claiming unemployment benefits while trying to create a debut collection on a shoestring, saying in an interview that was included in the 2018 documentary *McQueen*, "I bought all my fabrics with my dole money."

McQueen's first collection was entitled Taxi Driver, referencing Martin Scorsese's 1976 film of the same name, but also giving a deliberate nod to his father's profession. From the very beginning of his career, McQueen wove the twin threads of autobiography and cinematic inspiration into all that he created.

OPPOSITE These rare early design drawings by Alexander McQueen were made during a business trip to visit Italian manufacturers in the mid-1990s. The wonderfully fluid sketches relate to design templates for his S/S 1996 show The Hunger.

OPPOSITE
McQueen's iconic
"bumster" trouser,
shown at his debut
New York show in
March 1996, was one
of his earliest designs.
Despite shocking
onlookers, the style
filtered quickly down
to the high street in
the form of super-
low-cut jeans and
trousers.

In 1993 McQueen was chosen by the British Fashion Council as one of six young British designers to have their work shown during London's Fashion Week. But far from the theatrical shows that would distinguish him later in his career, his first collection was presented hung on mismatched hangers from a single clothes rail in a room at the Ritz Hotel.

The clothes, some emblazoned with the image of Robert de Niro's *Taxi Driver* character Travis Bickle, were a riot of sequins feathers and jewels, completely unlike the minimalist aesthetic favoured by his contemporaries. The most iconic garment in the collection was the "bumster" trouser, so daringly low-cut that the cleft of the buttock was revealed. In an interview with the *Guardian* about the collection, McQueen denied that his inspiration had come from the notoriously low-slung jeans worn by builders, saying instead: "That part of the body – not so much the buttocks, but the bottom of the spine – that's the most erotic part of anyone's body, man or woman."

In his very first collection, McQueen flew in the face of respectability and, in so doing, declared that he was a designer unafraid to push boundaries. As Andrew Bolton, the curator of the 2011 McQueen retrospective *Savage Beauty* at the Metropolitan Museum of Art, put it:

> *"He was very much about anarchy and about the anarchy of the British street, the anarchy of British music, and trying to, again, harness that into his clothes. And the bumster was one of the garments that, very early on, would make his reputation as this provocateur."*

Virtually no clothes survive from the collection: legend has it that McQueen, eager to celebrate but too penniless to pay to keep the clothes in the Ritz cloakroom, bundled them into bin bags and left them outside the bar he went to. Inevitably, they

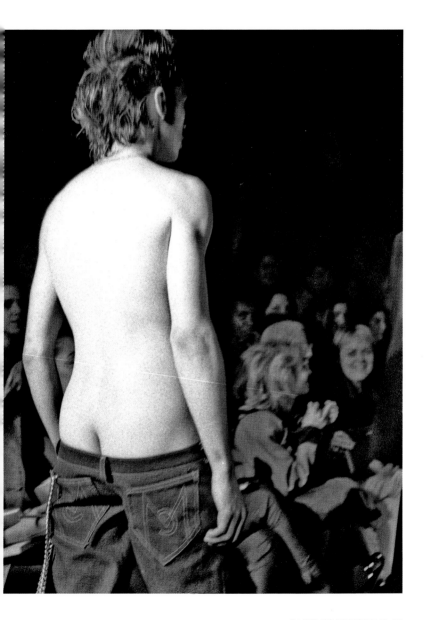

went missing. Only one pair of original bumster trousers survived. The hastily sewn pair, which McQueen borrowed back in 1996 to copy for the catwalk, were made in 1992 for McQueen's friend, the drag artist Trixie Bellair. In 2014 they sold at auction for £3,500.

NIHILISM (S/S 1994)

McQueen's first catwalk collection, for S/S 1994 and shown at the Bluebird Garage, was named Nihilism, a typically dark moniker alluding to the philosophy that nothing really exists. As for the clothes, this translated into virtually translucent chiffon garments that barely existed themselves – and revealed much of the models' flesh beneath.

McQueen's love of the macabre revealed itself in a cellophane dress, spattered with rust-coloured paint to mimic bloodstains. The sexuality that oozed from the models was aggressive; they strode down the catwalk exposed in unbuttoned men's shirts, simultaneously flipping their middle finger at the audience. The bumster trouser featured, teamed with cropped metallic tops so the eye was drawn even more acutely to the naked midriff, along with the inevitable signature sharp tailoring, here with an exaggerated silhouette. McQueen's technique – of tailoring from the side to contour the body perfectly – contributed to the period-looking tailcoat effect that so many of his jackets and coats have.

From this earliest show it was clear that McQueen had a huge amount of confidence in his design vision. The jury was still out, however, on his morals. As the *Independent* put it at the time, in a show review entitled "McQueen's Theatre of Cruelty":

> *"McQueen, who is 24 and from London's East End, has a view that speaks of battered women, of violent lives, of grinding daily existences offset by wild, drug-enhanced nocturnal dives into clubs where the dress code is semi-naked."*

BANSHEE (A/W 1994)

McQueen's second show, Banshee, for A/W 1994–5, was presented at London's Café de Paris. It took its inspiration from the old Celtic legends of the evil banshee who wailed at the sound of a sinking ship and, it was believed, could be seen washing blood from clothes of the men about to die.

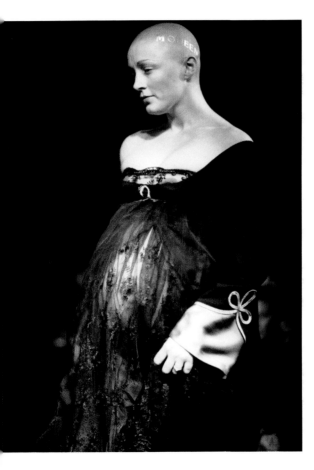

LEFT McQueen loved to shock, and the appearance of a heavily pregnant skinhead model, his name stencilled on her head, was a striking contrast to the Elizabethan-style black lace dress she wore.

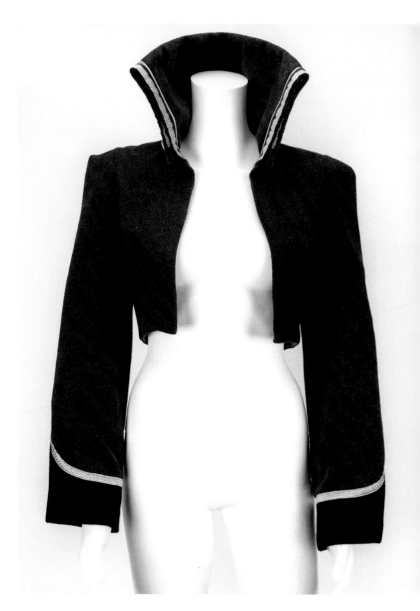

OPPOSITE This military-style jacket from McQueen's Banshee collection is made from black coating wool and features an extra-high stand collar, empire-line sleeves and gold braiding. The armpits are slashed open in typical McQueen style.

Again, the inspiration was historical, with Elizabethan-style gowns in black and white, one of which was shockingly sent out on a heavily pregnant skinhead model who had the word "McQueen" stencilled onto her naked head. Isabella Blow, also sporting a sprayed silver "McQueen" (although misspelled) on her head, modelled a purple shirt with an exaggerated collar.

Tailored jackets and cutaway knitwear offered more structured options within the collection, and a series of black and silver chiffon shirt dresses featuring prints by Simon Ungless were surprisingly wearable. Overall, there was a softer sense of gothic whimsy compared to his first, harsher collection, and McQueen was beginning to make some sales through Pellicano in South Molton Street.

THE BIRDS (S/S 1995)

McQueen's third catwalk show, often the make-or-break collection for an up-and-coming designer, was for S/S 1995. The show was held at Bagley's, a seedy warehouse more used to hosting drug-fuelled raves, and for it McQueen once again delved into film archives, this time taking as his inspiration Alfred Hitchcock's iconic 1963 horror film *The Birds*, starring Tippi Hedren. The thriller, with its flock of crazed birds that viciously attack humans, was a favourite from McQueen's childhood.

Hedren's sexy, 1950s styling, in the form of pencil skirts and figure-hugging dresses, was obviously a jumping-off point for the designer, but the destructive madness of the birds translated into deconstructed tailoring as well. Simon Ungless and Andrew Groves, McQueen's then boyfriend, designed prints for the show, including a swallow motif and tyre tracks, inspired by the scene in which everyone is fleeing the possessed birds in their cars.

Ungless is quoted in a 2015 piece for *The Cut*, describing how this particular scene caught McQueen's imagination: "Complete

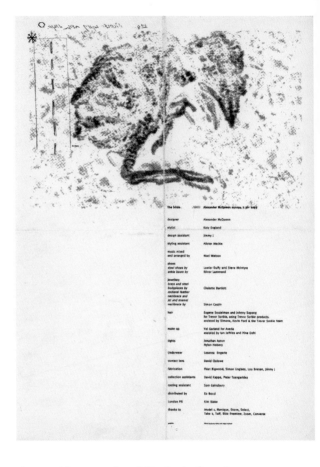

RIGHT McQueen's show invitations were often disturbing. This invitation for his S/S 1995 show The Birds featured the blurred image of a dead chick.

The birds. Alexander McQueen s/s1994 7.30- 1995

designer	Alexander McQueen
stylist	Katy England
design assistant	Jimmy J
styling assistant	Alister Mackie
music mixed and arranged by	Noel Watson
shoes steel shoes by ankle boots by	Lawlor Duffy and Steve McIntyre Elinor Lammond
jewellery brass and steel bodypieces by cockerel feather necklaces and jet and enamel necklace by	Chalotte Bartlett Simon Costin
hair	Eugene Souleiman and Johnny Sapong for Trevor Sorbie, using Trevor Sorbie products. assisted by Simone, Kevin Ford & the Trevor Sorbie team
make up	Val Garland for Aveda assisted by Ian Jeffries and Hisa Dyhi
lights	Jonathan Aston Nylon Hoisery
Underwear	Lasanza Inganie
contact lens	David Oslowe
fabrication	Fleet Bigwood, Simon Unglass, Lou Brenan, Jimmy J
collection assistants	David Kappa, Peter Tsangarides
casting assistant	Sam Gainsbury
distributed by	Eo Bocci
London PR	Kim Blake
thanks to	Model 1, Manique, Storm, Select, Take 2, Tuff, Elite Premiere, Zoon, Converse

chaos and human vulnerability in the face of nature gone wrong."

McQueen always used a wide variety of textiles and in the early days these were usually, out of necessity, very cheap. For The Birds, he spotted a roll of unwanted plastic pallet wrap in the street. He took it home, transforming it as he wound it around a dressmaker's dummy, snipping here and there, into a

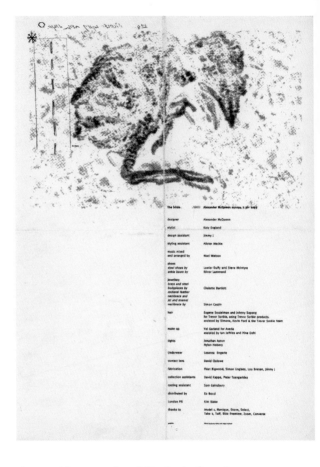

sleeveless transparent dress. Needless to say, a version turned up on the catwalk to critical acclaim.

This ability to create clothes out of very little, and in record time, was one of McQueen's most impressive talents. As Andrew Groves told Dana Thomas in *The Cut*:

> *"He put a huge piece of silk on a stand, cut a neck hole out of it, wound thread all around it, poured latex on it,* [added a] *slash down the back for a zipper and said, 'There's one dress.' Ideas like that were getting churned out every hour or so."*

The Birds also saw McQueen collaborate for the first time with both Simon Costin, the artist and set designer who would become so instrumental in the creation of McQueen's most iconic fashion shows, and stylist Katy England, who would become his creative director. Grand took Ungless's tyre-print design one step further by actually muddying a tyre and rolling it on the model's arms and torsos so the motif flashed from beneath their undone jackets. Thus, McQueen's vision of the Hitchcock scene, described gruesomely by the designer as "Birds, road, car tyre, splat!", was realized.

The show is widely credited with launching McQueen into the big leagues of fashion designers. However it also generated accusations of misogyny and violence towards women, which would follow him his entire career. The show is also interesting for the gender-defying appearance in this early show of corsetier Mr Pearl. The ballet dancer turned self-taught corset-maker, who had collaborated with Leigh Bowery, was spotted by McQueen wearing a tight corset at a nightclub. The designer asked him to walk for The Birds, which he did – wearing a tailored jacket and fitted red bird-print pencil skirt, his corset giving him a freakish-looking 18-inch waist. As he would do throughout his career, McQueen put what inspired him onto the catwalk, rather than what was expected.

HIGHLAND RAPE (A/W 1995)

If The Birds thrust McQueen into the upper echelons of fashion design, Highland Rape, for A/W 1995, confirmed that he belonged there, despite the controversy the show garnered. It was also his first collection to be shown in the official British Fashion Council tents. The first point to clear up is that the word "rape" was misleading. As Andrew Bolton, the curator of *Savage Beauty*, explained in the notes to accompany the exhibition:

> *"At the time, people thought the rape referenced*
> *the rape of women. But it was actually the rape of Scotland*
> *by England. The collection actually referenced the Jacobite*
> *risings of the eighteenth century and the Highland Clearances*
> *of the nineteenth century."*

RIGHT A triptych of garments on models' dummies awaiting completion for McQueen's A/W 95 Highland Rape show. The selection includes on the right a tailored stand-collar jacket, the body section made of the MacQueen clan tartan, with jeweller Shaun Leane's fob chain closure. On the left is a black and gold dripping "William Morris" sheath dress, the print is a Simon Ungless design for Alexander McQueen.

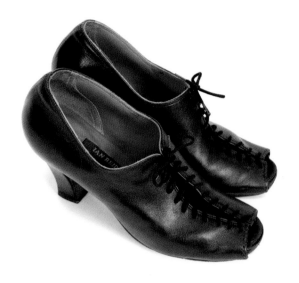

LEFT A pair of black, period-style shoes from McQueen's Highland Rape collection. The handmade, block-heeled black leather shoes were made by London's House of Beauty and Culture, a collective of independent designers known for their subversive designs during the 1980s and 1990s.

Despite McQueen's show notes including a passage explaining the historical references, the skeptics weren't convinced, and the show sent shock waves through the fashion press, generating harsh reviews. One of these was by Sally Brampton, who wrote in the *Guardian*, "It is McQueen's brand of misogynistic absurdity that gives fashion a bad name."

McQueen's case wasn't helped by the models who walked the bracken-strewn runway with distraught expressions, their breasts exposed and wearing clothes that had been slashed, torn and splattered with fake blood. McQueen defended himself, citing his Scottish heritage and telling *Time Out* magazine that the collection was "a shout against English designers … doing flamboyant Scottish clothes".

In particular, McQueen took issue with Vivienne Westwood, long a lover of glamourized tartan, albeit with a healthy side dose of punk. Despite the obvious similarities between the two designers, Westwood was not a fan of

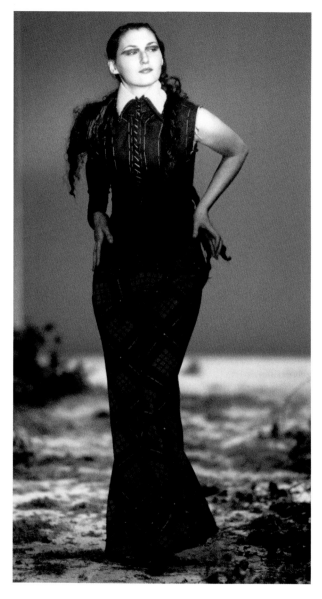

LEFT McQueen returned to the theme of his Scottish ancestry often. This outfit from the Highland Rape collection includes a sleeveless, deconstructed, tailored jacket with white starched collar and a long bias-cut skirt in the MacQueen clan tartan.

McQueen either, telling the *Sunday Times* in 2000: "His only usefulness is as a measure to zero talent."

Jeweller Shaun Leane, another long-time collaborator of McQueen's who was first commissioned by the designer to make fob watch chains for Highland Rape, was indignant when recalling the show 25 years later in an interview with *FW,* the magazine created by Judith Watt and former BA Fashion Journalism students at Central Saint Martins: "What me and Lee did, was that we dressed those girls for battle, but in a beautiful, empowering way."

Opinions on the message behind McQueen's Highland Rape collection might have been mixed but there was no doubt that the clothes themselves were masterful. The "bumster" trouser appeared once again, and this unlikely fashion icon would soon hit the mainstream when Madonna wore a pair in an advertisement for MTV, leading to a trend for low-slung hipster jeans.

The collection had a typically historical feel too. MacQueen clan tartan was heavily featured, including in the form of a slashed-open tailored jacket with a matching, beautifully cut bias skirt. Several outfits were finished with high collars, based on leather military neck "stocks", and trimmed with an Elizabethan-style white ruff.

Tartan was a motif that McQueen would return to again and again throughout his career. He felt extremely strongly about the commodification of traditional Scottish tartan and what it represented, and wanted to use his designs to expose the brutality of history rather than romanticize it. As Jonathan Faiers put it in an essay for the Metropolitan Museum of Art:

"Many designers who reference history display a form of historical seamlessness in which the past is perfectly and nostalgically recreated in the present. With McQueen, however, the reference is not as comfortable; the suture lines of his much-discussed 'surgical' tailoring techniques are still visible as uneasy grafts of history onto contemporary garments."

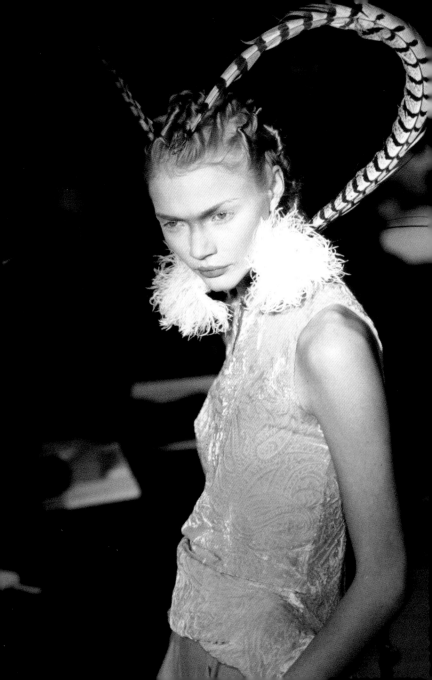

THE HUNGER (S/S 1996)

The buzz surrounding McQueen was growing, but this had not yet translated into profit, and so his S/S 1996 show The Hunger had a meagre £600 production budget. Perhaps in light of the need to sell his clothes, the collection was more commercially viable than McQueen's previous offerings – and with less shock value, although it did include his first use of live creatures, in the form of a plastic corset filled with worms.

DANTE (A/W 1996)

After his previous collection McQueen had signed a deal with Japanese backer Onward Kashiyama, giving his label a much-needed injection of cash. His next collection, Dante, was held in the baroque Christ Church in Spitalfields, built by Nicholas Hawksmoor, who was reputed to be a Satanist. The eerie, candle-lit church, styled with blood-red roses, was redolent of McQueen's beloved East End darkness and the

OPPOSITE Jodie Kidd modelling in McQueen's New York Dante show in 1996. She wears a crushed printed silk and velvet sleeveless bodice with long draped tail and white ostrich feather collar. Her headpiece is made from ornamental pheasant tail feathers, which were sourced by Simon Ungless's gamekeeper father.

BELOW A rare behind-the-scenes shot from the personal album of Ruti Danan showing a young Alexander McQueen working on a fitting with a male model.

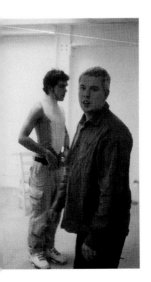
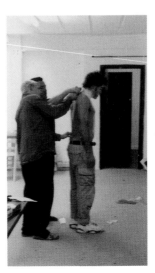

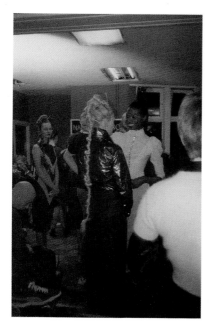
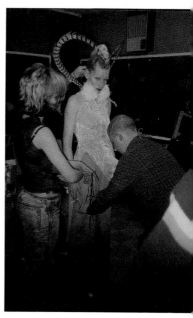

ABOVE Two rare backstage shots of McQueen including one of Jodie Kidd, with her iconic curved pheasant feather headpiece, receiving final adjustments before his A/W 1996 show.

Jack the Ripper themes that inspired his graduate collection. Some of his Huguenot ancestors had even been buried in the very same church. And if anyone was in any doubt as to McQueen's obsession with death, there was a skeleton seated in the front row. The religious backdrop was maintained when the collection was shown a second time at a disused synagogue on New York's Lower East Side.

Named for the author of the *Divine Comedy,* an allegorical narrative that examined the soul's wandering journey through the afterlife, McQueen took the theme of religion further, to examine war and peace throughout the years. He told *Women's Wear Daily* at the time,

"I think religion has caused every war in the world, which is why I showed in a church."

The irreverence of McQueen's choice of a church for his venue was deliberately shocking, and the staging of the show emphasized his defiance. Models, including Kate Moss, wore eye masks bearing the crucified form of Christ on them and stuck their tongues out as they walked the crucifix-shaped catwalk, all to a soundtrack that included haunting Gregorian chants.

The violence of war was impossible to ignore as McQueen, inspired by the gritty Vietnam war photography of Don McCullin, took the images and asked Simon Ungless to print them onto fabrics for his collection. McQueen hadn't asked for McCullin's permission, though, so the original garments had to be destroyed, but the pair became friends and over the years, the photographer took many portraits of both McQueen and his collections. The black and white printed jackets and coats were modelled by youths plucked from the East End and dressed as the gangs of drug-dealing teens from *Mixed Blood*, the 1984 film by Andy Warhol acolyte Paul Morrissey.

Earlier historical battles were referenced by military and naval-style frock coats and cadet trousers, although the latter were given the bumster treatment. Victoriana, a recurrent theme for McQueen, was realized by plenty of lace, including mourning veils, and stylized lilac corsetry, supplied by Mr Pearl. In contrast, bleach-splashed denim injected a modern, street-punk edge.

This was a more decadent collection from McQueen who, for the first time, chose luxurious fabrics rather than the cheap materials he had often been forced to use thanks to a restrictive budget. Mongolian lambswool and white cashmere were just two examples. With the financial backing of Onward Kashiyama, McQueen was able to have his suits made to the highest standards in Italy, although there was plenty of the usual art-school inventiveness too, as described in *AnOther*

RIGHT Alexander McQueen backstage, assessing a model who is wearing the gold braid coat that was eventually modelled by Helena Christensen in his Dante show.

magazine's retrospective of the landmark show in 2018: "The draped devoré velvet dresses and skirts were made in-house and the bleached denim was knocked up by Andrew Groves in the bath of his studio flat."

Dante was also the show where McQueen first collaborated with milliner Philip Treacy, who created some of the first of McQueen's iconic animal headpieces. The dramatic stag's skull with horned antlers was sourced by Ungless from his gamekeeper father. The hunting theme, as well as McQueen's bird obsession, was further emphasized by the appearance of aristocratic model Stella Tennant, who carried a live falcon on her wrist.

Treacy, who would go on to create many remarkable pieces for McQueen, told *The Cut* in 2015:

"Dante was the show that made him, actually. The thing is, everybody loves Alexander now, but they didn't at the beginning. And when he did that show, suddenly people could see his potential, because it was beautifully done."

BELLMER LA POUPÉE (S/S 1997)

McQueen's S/S 1997 show was inspired by the fetishistic German artist Hans Bellmer and his 1936 tableaux, *La Poupée* (translated as "The Doll"). Bellmer created his disturbing images by photographing mechanical dolls, which he took apart and reassembled in strange, mutilated forms, posing

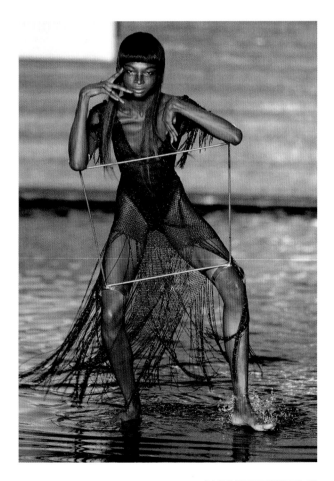

RIGHT For the Bellmer La Poupée show, model Debra Shaw wore a piece of Shaun Leane's "contortion" jewellery, consisting of a metal frame attached to her elbows and thighs. McQueen was heavily criticized by those who believed this was an allusion to slavery.

M^CQUEEN

BELLMER
'Le poupee'
S/S 97
Creative Director: Katy England
Producer: Sam Gainsbury
Art Director : Simon Costin
Studio Assistants: Helen Rafferty, Bernhard Willhelm,
Sarah Heard, Sheila Dass. Sam Davies, Lucy Burrows.

Lighting Director: Simon Chaudoir
Head of Lighting : Dave Tyler
Lighting supplied by: AFM lighting

Music by: Dominic Thrupp (Dom T)
Make- up: Topolino and team.
Hair: Barnabe @ Atlantis and team.
Men: Mira & team, make- up for Shu Uemura, hair for Aveda.
Catwalk co-ordinator: Russel Marsh and team.

Men and Womens shoes by: Lawless for Alexander McQueen
Silver headpieces and jewellery by:
Shaun Leane for Alexander McQueen 0171 405 4773
Quill @ leather accessories by:
Dai Rees for Alexander McQueen 0171359 4874
Butterfly cage by : Anthony Costin

Special textile fabrications by: Eley Kishimoto
Embroidery : Seoidra design
Underwear by: Warners & Sock Shop
Dressers: Thanks to Sidonie and team
Security supplied by : Panther Security 0171 242 2729
Press: Trino Verkade, Mehala and Amie.

Thanks to Phil Clark, Jodie Paget le Tour, Tony Simmons,
Gary Wallis @ AFM, Vince and Kelly, Paul Nagal, Janet Fischgrund,
Gary Stringer from Reef, Francesca Cutler @ Active Management,
the team at Jackie Cooper PR, Helen Archer, Issy Virdin,
Haidee Finlay Levin & Dome for hair extensions.

With grateful thanks to **Tanquarey Gin** for their support.

Hans Bellmer : Le Poupee - The Doll 1949

LEFT AND BELOW
An invitation to
McQueen's S/S 1997
Bellmer La Poupée
show featuring one of
surrealist artist Hans
Bellmer's unsettling
images of mutilated
mechanical dolls,
from which McQueen
got his inspiration.

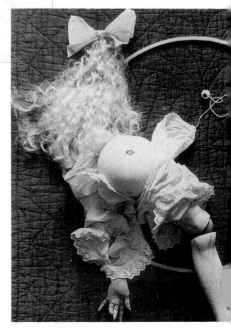

hem in various domestic settings. With a strong surrealist undercurrent, the pieces, seen at the time as a reaction against the Nazi concept of the perfect Aryan woman, appealed to McQueen, who was fascinated by the idea of body fascism.

Throughout his career McQueen challenged assumptions about how bodies should appear, often distorting model's proportions through the cut of his clothes, hair, make-up and jewellery. The "bumster" trouser, for example, dramatically elongated the torso. Often, the effect was intended to be erotic. But in La Poupée, McQueen's shock tactics were considered by many to go too far.

The most criticized was the "contortion" jewellery McQueen commissioned Shaun Leane to create, in particular a metal frame worn by Black model Debra Shaw over a virtually transparent net dress. With the frame fastened to her elbows and knees, Shaw juddered uneasily down a water-covered catwalk, her movements reminiscent of Bellmer's mechanical dolls. The connotations of slavery were inescapable, but McQueen denied his creations were in poor taste.

Along with translucent fabrics and exaggerated proportions, it was the sculptural headpieces, synthetic doll-like hair and metallic make-up that made the overall effect of the collection so disturbing. Fully embracing the show's theatrical potential, McQueen directed the girls to walk provocatively, as if in a performance, exaggerating their movements in a way that contrasted dramatically with the typically anodyne appearance of runway models.

The finale to La Poupée featured a model walking out bearing a translucent polygon-shaped box filled with butterflies. The effect of McQueen's show was unreal, and while the fashion world were unsure about what it all meant, there was no doubt he was a master of theatrics.

THE HOUSE
OF GIVENCHY

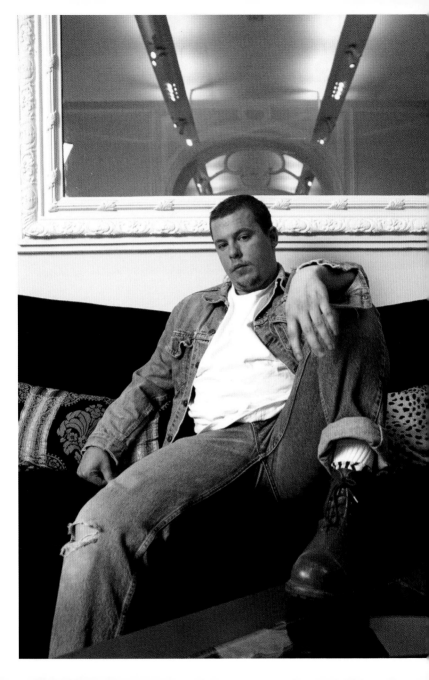

A SOJOURN
IN PARIS

Hubert de Givenchy, the legendary French couturier, retired in 1995. Bernard Arnault, CEO of the fashion house's parent company LVMH, turned to the world of young British designers, hoping to find a successor who would inject fresh energy into the staid world of French haute couture.

Although Isabella Blow encouraged Arnault to choose McQueen straight away, the job first went to John Galliano – but a year later Galliano moved to Dior and McQueen was offered the creative directorship of Givenchy.

The choice of the "bad boys" of British fashion to head up two of the most traditional Paris fashion houses was controversial. At the time the *New York Times* described the move as "a blow to French cultural pride", saying that McQueen and Galliano "are famously working class, wild and drawn to such provocative impulses as buttocks-baring trousers and spray-painted leather suits."

OPPOSITE Alexander McQueen photographed in the Givenchy salon in Paris in 1996, shortly after taking up the role of artistic director.

Initially, McQueen himself was also unsure. In Judith Watt's book *Alexander McQueen: Fashion Visionary*, she explains that the designer was almost talked out of accepting the role, quoting Alice Smith, part of the fashion consultancy duo Smith & Pye who supported McQueen in the early 1990s: "I told him not to do it – the place wouldn't suit him... He wouldn't be able to cope with the snobbery of Paris. He said 'Yeah!'"

But a million-pound deal was too good to turn down, and in October 1996, McQueen headed to Paris. Controversially, McQueen took the stylist Katy England with him – but not Isabella Blow, who, having partly facilitated the deal with Givenchy on the assumption she would be given a paid role at the couture house, was devastated, not least because she needed the money.

McQueen's East End background and theatrical design aesthetic could not have made him more different to the aristocratic and understated Hubert de Givenchy, yet he shared the legendary designer's technical brilliance. Keen to show what a working-class Brit could do, the outspoken McQueen arrived at Givenchy arrogantly proclaiming his predecessor was "irrelevant".

His first show, for Givenchy's S/S 1997 haute couture line, was entitled Search for the Golden Fleece. Inspired by Ancient Greece, it focused on a palette of gold and white, reminiscent of both the golden era of Hollywood and the house motif. It was full of the bizarre elements that fashion watchers had begun to expect from McQueen, including a headpiece of sheep's horns and a model wearing giant wings while perched on the first-floor balcony of the École des Beaux-Arts.

Unfortunately, the show was not well received, with Amy M. Spindler of the *New York Times* saying, "it seemed too strange for Givenchy couture and not creative enough for his own name". Marion Hume, writing in the *Financial Times,*

agreed: "What he left out was a dark side."

A year later, McQueen also admitted he was unhappy with his debut for Givenchy, telling *Vogue* succinctly in October 1997, "I know it was crap."

McQueen put himself under huge pressure juggling both couture and ready-to-wear for Givenchy in Paris and continuing to design and stage shows for the Alexander McQueen label in London. However, his critical success under his own name undoubtedly went a long way in shoring up his credibility at Givenchy.

BELOW Alexander McQueen emerged to applause at the end of his debut show for Givenchy, Search for the Golden Fleece.

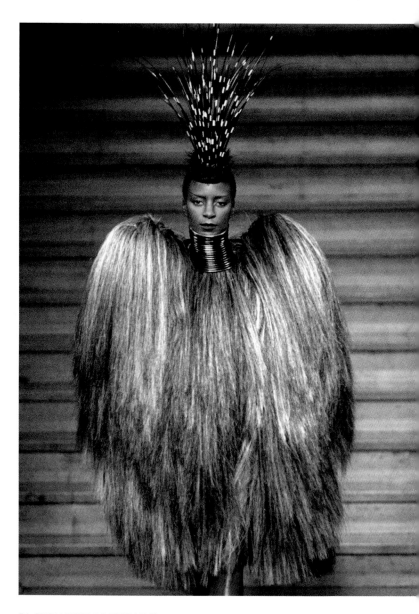

OPPOSITE For A/W
1997 McQueen
presented a hair-
like silver dress
with a silhouette
that echoed bird
wings, the imagery
enhanced by the
model's porcupine-
quill headpiece. Her
neck-ring jewellery
by Shaun Leane is
inspired by that of
the Kayan tribe of
Myanmar.

His next Givenchy collection was ready-to-wear for A/W 1997, and was named Lady Leopard. The show saw models, clad in sharply tailored animal-skin coats, their tight skirts slit thigh-high, prowl through a former slaughterhouse. McQueen explained that he had taken his inspiration from the underbelly world of drag queens and low-budget sexploitation films. He told Harriet Quick in the *Sunday Telegraph*: "I want to take Givenchy onto a new platform; it is the sexual energy that is important."

Lady Leopard was more positively received, with Iain R. Webb in *The Times* opining: "This collection proved that the young punk from East London is now ready to play with the big boys."

McQueen's first two shows for Givenchy had been relatively tame for a designer renowned for his love of the macabre and ability to shock, but his second haute couture show was far more contentious.

Devised in collaboration with Simon Costin, and entitled Eclect Dissect, the show was presented at the Université René Descartes medical school – appropriate, given its subject matter. It recalled the story of an 1890s surgeon who killed women around the world and then put them back together piecemeal. The gothic staging included medical specimens in jars as well as live ravens in huge cages at either end of the runway.

Every outfit was a brilliant assemblage of different styles, periods and cultural references, evoking the far-flung places where the morbid surgeon found his victims. McQueen's inspiration ranged from the tribes of Africa and the geisha women of the East to British Victoriana and futuristic headpieces. The horrific aspect of stitching the women's body parts back together was reflected in outfits such as a black leather dress with a collar of red pheasant feathers, embellished by vulture skulls made of resin.

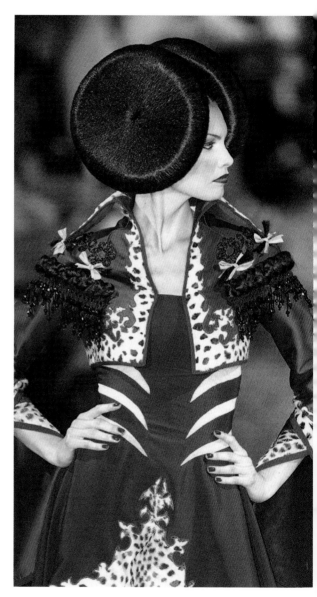

RIGHT AND OPPOSITE One of McQueen's more successful collections for Givenchy was Eclect Dissect, based on the macabre tale of a murderous surgeon. He ranged across cultures, styles and periods to create rich and luxurious outfits. These designs highlight McQueen's use of colour, embroidery and tactile embellishments, such as his beloved feathers.

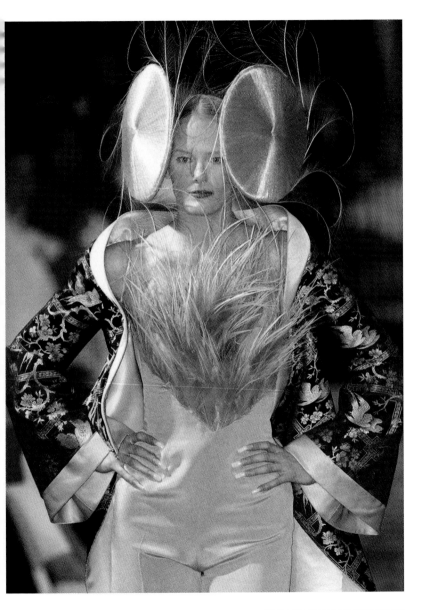

Other garments, such as a series of silk satin kimonos with embroidered sleeves, were less gruesome, and showed McQueen's masterful grasp of clothing construction. He also included a good amount of his personal favourites: tartan and black lace. His obsession with birds – both live and stuffed in the Victorian tradition of taxidermy – had followed him to Givenchy; one model held a dead falcon, while another appeared in a hat that had a live bird trapped within it. Other finishing touches included a coiled collar necklace by Shaun Leane, inspired by the neck-stretching jewellery of the Kayan tribe in Myanmar.

But one person who did not like what McQueen was doing in Paris was Hubert de Givenchy himself, who was quoted in the *Daily Telegraph* as saying: "I glance at the fashion pages to see what's happening at Maison Givenchy. Total disaster."

Over the next couple of years, McQueen veered from showing clothes on plastic mannequins and styling models in a clumsy reference to the android character Rachael in the iconic 1982 film *Blade Runner* to attempting commercial success with a series of unexciting outfits. The contrast with the designs he was producing for his own label – which were receiving rave critical attention – was huge.

McQueen was deeply unhappy and furious at what he considered undeservedly poor reviews, blaming the culture of control at the haute couture house. He told the *Observer* in 2001: "I had no support from the French. I'd design, they'd change the whole thing, and then the press would give me the flak for it. It was a case of too many cooks."

McQueen's position at Givenchy finally became untenable when he committed the ultimate sin and sold a controlling stake in his own Alexander McQueen label to LVMH's rival, Gucci Group. He left Givenchy in 2001 to return to London.

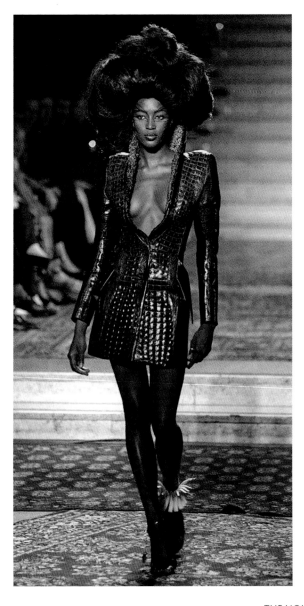

LEFT An elaborately coiffed Naomi Campbell wears a tailored reptilian dress with padded shoulders, accessorized by an animal bone anklet for Givenchy A/W 1997 haute couture.

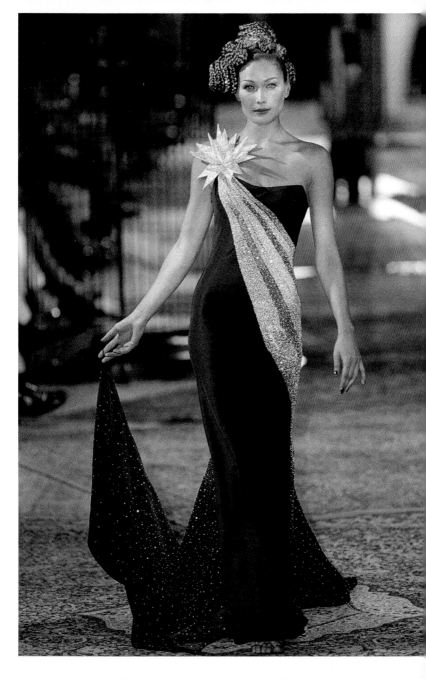

On reflection, fashion commentators admit the critics treated McQueen's collections for Givenchy poorly, with Lisa Armstrong writing for *Vogue*: "When I look back I think it aged pretty well … These things get very hyped up to create a drama. It was a lot of pressure to put on such a young person."

RIGHT Despite the challenges he faced at Givenchy, McQueen did manage to introduce a little of his own signature. Take, for example, this elegant geisha-inspired outfit of a crossover, tailored day dress from McQueen's Givenchy S/S 1999 collection. It features a geometric print with a perforated lilac floral-printed leather corset and matching sculptural hat.

OPPOSITE Here, McQueen has perfectly captured the Hollywood glamour combined with regal elegance that epitomized the House of Givenchy. Model Carla Bruni wore a black and silver bias-cut evening gown adorned with sparkling crystals and a starburst detail on the shoulder.

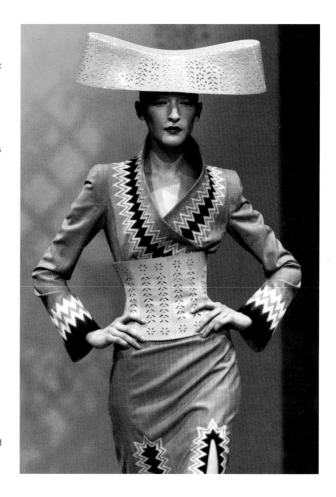

BACK IN
LONDON

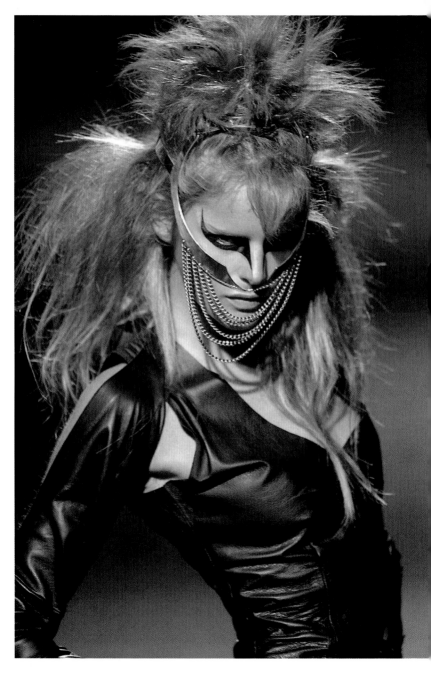

THE EVOLUTION OF A FASHION VISIONARY

A cockney at heart, McQueen was most at home in London, where he could give free reign to his creative genius and throw himself into presenting increasingly theatrical shows for his Alexander McQueen label.

IT'S A JUNGLE OUT THERE (A/W 1997)

At the same time as McQueen was sending louche, leopard-skin-clad models down the Givenchy catwalk, he was expanding the theme for his own label in London. In marked contrast to the sanitized set that he used in Paris, It's a Jungle Out There was set against the backdrop of Borough Market – in medieval times, it had been the city's first red light district. In 1599 Shakespeare's Globe Theatre opened nearby, making the area a haven for both theatre and the sex trade, a perfect locale for McQueen's erotic, flamboyant fashion.

OPPOSITE A typical outfit from It's a Jungle Out There. The dress is made from faux cow hide with a stencil-cut floral pattern. The dramatic kohl eyeliner was inspired by the Thomson's gazelle, an innocent creature preyed on by lions and hyenas, which McQueen felt accurately conveyed his sense that we are all being metaphorically eaten alive.

The set was built around vast sheets of corrugated iron riddled with fake bullet holes, and wrecked cars – a direct reference to the 1978 film *Eyes of Laura Mars* – with dry ice pouring out from both sides. The dark lighting and smoky atmosphere gave the production a sinister edge. The sharply tailored clothes, costume-like in their drama, were made from animal hides, black leather and acid-washed denim. Antlers, claws and taxidermy crocodile heads exaggerated the wildlife theme.

The models were styled with messy hair and dramatic kohl eyeliner, their eyes covered in black contact lenses. The inspiration for both the make-up and the story behind the show came from a singularly innocent creature, the Thomson's gazelle, which McQueen had seen in a nature documentary. He was quoted in the *Daily Telegraph*, reflecting on the landmark show as saying: "I watched those gazelles getting munched by lions and hyenas and said, 'That's me!'"

He told *Time Out* magazine at the time:

> *"It's a poor little critter – the markings are lovely.*
> *It's got these dark eyes ... horns – but it is the food chain of Africa.*
> *As soon as it's born it's dead, I mean you're lucky if it lasts a few*
> *months, and that's how I see human life, in the same way.*
> *You know, we can all be discarded quite easily ...*
> *You're there, you're gone, it's a jungle out there!"*

The show was remembered as much for its theatrics as for its fashion, including a dramatic moment when one of the cars almost caught fire. But with hindsight, the philosophy behind it said a lot about how McQueen felt at the time about his place in the fashion industry, and his disquiet about his role at Givenchy.

UNTITLED (S/S 1998)

McQueen's S/S 1998 show was not, in fact, originally called

RIGHT AND BELOW
The invitation
to McQueen's
It's a Jungle Out
There features a
stylized Nick Knight
photograph of model
Debra Shaw in a state
of transformation.

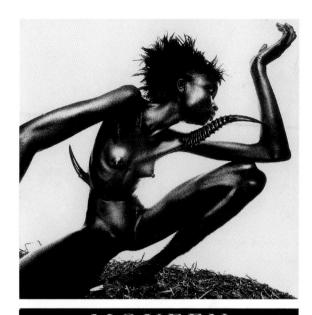

MCQUEEN

IT'S A JUNGLE OUT THERE!

9PM THURSDAY 27TH FEBRUARY
BOROUGH MARKET, 8, SOUTHWARK STREET SE1

FOR MUM AND DAD

PRESS ENQUIRIES UK: TRINO VERKADE / ALEXANDER MCQUEEN TEL: 44 171 729 0537 / FAX: 44 171 256 1618
DISTRIBUTION ENQUIRIES UK: MAUD 'O' KEEFFE / ONWARD KASHIYAMA / TEL: 44 171 349 9906 / FAX: 44 171 352 8294
PRESS & DISTRIBUTION ENQUIRIES USA: ONWARD KASHIYAMA / PIERRE ROUGIER / LAN LE / TEL: 212 629 6160
PRESS & DISTRIBUTION ENQUIRIES JAPAN: MIKIKO KUROSHIMA / HUG STOP / TEL: 81 3377 082/2 / FAX 81 3377 07684

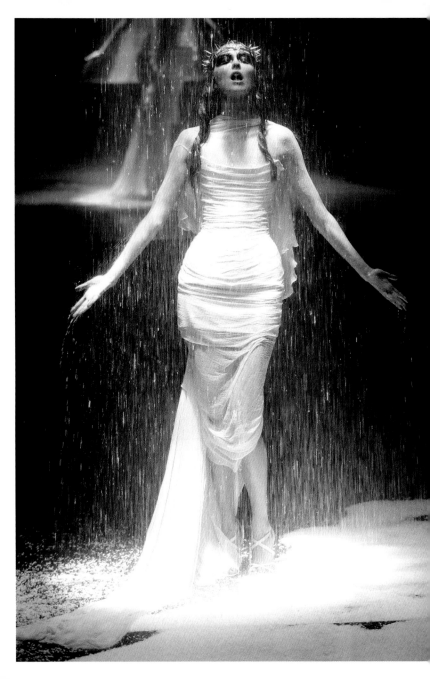

Untitled but Golden Shower. As part of the show's theatrics, models were drenched in golden-hued water from a sprinkler, a more modest take on McQueen's contentious choice of title which backers, American Express, had understandably balked at. Rather petulantly, McQueen refused to officially rename the show so it remained Untitled.

The runway was made from water-filled Lucite tanks lit with an eerie ultraviolet light and the models were styled in long, sleek wigs and darkly fringed false eyelashes. As in his previous show, the backstory was evolution, but rather than the plains of Africa, this show referenced "the emergence of amphibious creatures from primeval mud onto land", as Judith Watt put it, in her book *Alexander McQueen: Fashion Visionary* (2014).

The models were dressed in form-fitting snakeskin dresses and various garments made only from bondage-style strips. A top of slashed fringes of leather, the model's naked breasts on display, implied a tooth-and-claw fight for survival. Despite this, the overall aesthetic was more minimal than in many of McQueen's collections and the finale saw every model dressed in white, drenched by the "golden shower", their mascara running and the fabric of their clothes slowly turning transparent.

JOAN (A/W 1998)

For A/W 1998 McQueen harked back to the death of Catholic martyr Joan of Arc, who was burned at the stake, as well as to the tragedy of the murders of the Tsar Nicholas II and his family. Never one to shy away from the image of death, McQueen included printed images of the Tsar's children on several of the garments.

The show was held at Victoria's Gatliff Road warehouse, a decrepit former bus depot. For this season McQueen chose fire as his element du jour, covering the Perspex runway in fake

OPPOSITE True to the show's original name, the finale featured models dressed in virginal white, some wearing Shaun Leane's metallic crowns of thorns, being drenched by a golden-hued shower.

OVERLEAF This stunning outfit consists of a backless halterneck silk top and a circular skirt made entirely from fan-like strips of lightweight balsa wood, in a laser-cut pattern that flared dramatically out from the model's waist.

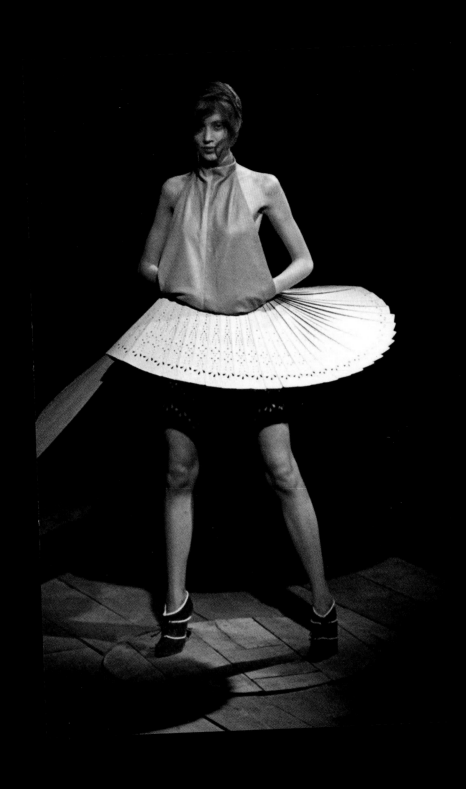

volcanic ash. The medieval Joan of Arc reference was literally embodied by dresses made of chainmail and leather "armour". The colour palette of blood red, silver and black evoked both the instruments of war and the death of the simple peasant girl who led France to victory against the English on the word of God. With a blunt directness typical of McQueen, the sexualized body language of the models was thrust uncomfortably against the murder of innocents.

The collection was texturally rich and included McQueen's signature tartan – the execution of Mary, Queen of Scots was another inspiration behind the show – moulded black leather and denim, and sequinned embellishments. One of the most iconic looks was a short dress of red lace with a full-length train which entirely covered the model's face. It was later worn by Lady Gaga to the MTV Video Music Awards in 2009, the singer customizing the outfit with a crownlike hat.

In reference to Joan of Arc's habit of wearing men's clothes, McQueen's outfits were sometimes androgynous – or he completely reversed gender roles, dressing male models in corsets and dresses.

The art direction of the show was typically dramatic. Models were hauntingly pale, with blonde wigs or semi-shaven heads, and their eyes appeared bloodied by the red contact lenses they wore. But the most sensational part came at the show's finale, described evocatively by Kate Bethune from the Victoria and Albert Museum: "a satanic ring of flames encircled a lone masked model in a red ensemble, which echoed flayed flesh; bugle bead skirt suggestive of dripping blood".

NO. 13 (S/S 1999)

McQueen's thirteenth collection, labelled simply with the number which presumably tickled McQueen, who laughed in the face of superstition, was a tribute to the Arts and Crafts

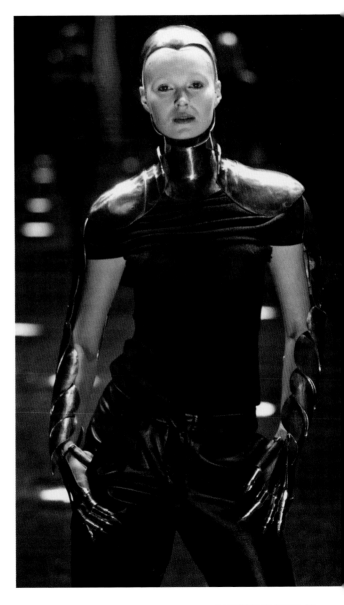

RIGHT A red-eyed, battle-ready model poses on the catwalk for McQueen's A/W 1998 show Joan. She is dressed in a softly pleated black velvet tunic and leather trousers with metallic "armour". Her high-collared headpiece and body armour finish in long pointed claws.

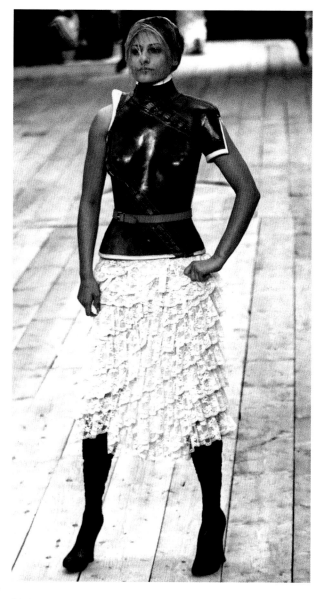

LEFT Bodily
perfection, disability
and its role in fashion
was an issue on
which McQueen's
thirteenth collection
homed in. To this
end, the double
amputee model
Aimee Mullins
appeared wearing
a moulded leather
corset and silk lace
skirt with beautifully
carved wooden
prosthetics by Bob
Watts and Paul
Ferguson.

movement and drew on several of the designer's favourite themes. Firstly, the rejection of bodily perfection, which he had examined two years earlier in his macabre Bellmer La Poupée collection, was embodied by the double amputee model Aimee Mullins. McQueen had commissioned beautifully carved wooden prosthetics for her to wear, which were so convincing that several stylists assumed they were boots and asked to borrow them.

Secondly, he revealed a fascination with technology – not always the most obvious of McQueen's inspirations, given his frequent use of Edwardian and Victorian imagery. But the man-versus-machine rhetoric was certainly one that fascinated the designer and was borne out in the show's finale.

It was one of the most dramatic scenes ever to appear on the catwalk. Shalom Harlow, who 10 minutes earlier had been walking the runway in a typical McQueen outfit of ultra-low bumsters and a cutaway frock coat, appeared wearing a virginal

BELOW For the thrilling finale of McQueen's S/S 1999 show, two car-painting robots sprayed model Shalom Harlow's virginal white dress with graffiti-like patterns as she flung her arms while turning on a rotating platform.

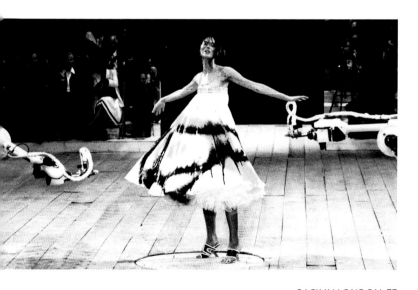

white dress – a play, perhaps, on the wedding dress that traditionally appears at the end of couture shows.

Thus far the show had been relatively serene, models gliding along in exquisite tailoring and romantic lace dresses, lulling the audience into a false sense of security. But all that changed when the wooden turntable on which Harlow stood started to rotate and two robots, designed for spray painting cars, started to pelt her with bursts of black and neon yellow paint. The model twisted and turned in a dance-like fashion, appropriate given that she was a former ballerina, and the white dress, along with her face and hair, became saturated with graffiti-like patterns.

Reminiscing to *Vogue* magazine, Sam Gainsbury, who produced the show with her partner Anna Whiting, recalled: "Lee wrote precise instructions to the factory about how he wanted the machines to move, joint by joint, like spitting cobras. And it worked, exactly."

The show was applauded as his greatest yet, a legendary piece of performance art that would go down in the annals of fashion history. As Sarah Mower reflected for *Vogue* in 2018:

> *"Nature versus the machine, fear, and sensation were lifelong themes of McQueen's … he established a fearless experimental way of creating happenings that took fashion beyond mere displays of clothing and into the realms of the unforgettable, emotional experience."*

THE OVERLOOK AND THE EYE
(A/W 1999 AND S/S 2000)

McQueen's show The Overlook was inspired by Stanley's Kubrick's 1980 horror film *The Shining*. A magical winter performance, made eerier by the sound of howling wolves, was staged inside a Perspex box that evoked a Victorian snow globe,

OPPOSITE McQueen created an eerie winter snow scene, based on Stanley Kubrick's horror film *The Shining*, for A/W 1999. This crystal-encrusted corset is made to resemble stalagmites and is teamed with bumster trousers.

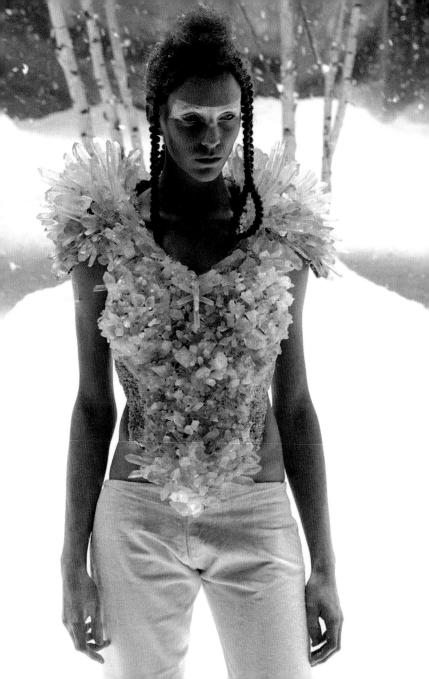

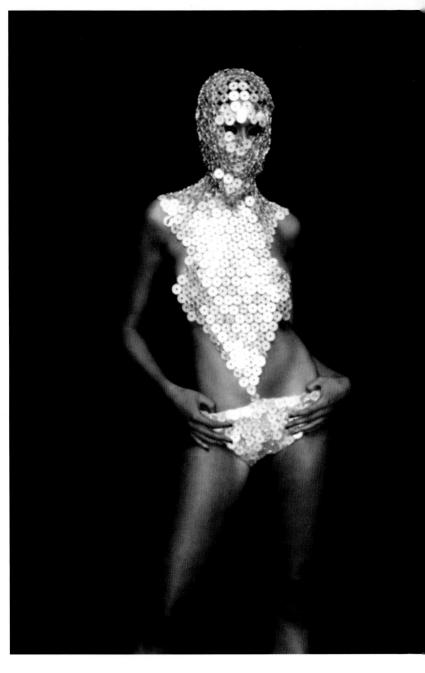

complete with circling ice skaters. The outfits included cold-weather chunky knitwear and shearling, tailored leather and voluminous skirts, as well as a stunning Shaun Leane-designed coiled metal corset.

The Eye, shown in New York, used dyed, jet-black water as a theatrical show medium. The influence behind the collection came from the Middle East, with Gisele Bündchen in a fringed, embroidered head covering. The intention was to show female empowerment as McQueen yet again rejected cultures of suppression and called forth his "warrior" women.

ESHU (A/W 2000)

This collection was named for the Yoruba tribe's deity Eshu, a prankster god who serves as a messenger between humans and the spirit world. There were plenty of Nigerian sartorial influences, including masks, high collars of ringed neck jewellery and a spiked mouthpiece, but it was the voluminous silhouette of the Yoruba tribe that caught McQueen's imagination.

McQueen blended Victorian mutton-leg sleeves with modern tailoring, bumster trousers and slim, elegant dresses and included some standout pieces such as an oversized black coat made from woven synthetic hairpieces. The singer Björk later wore a dramatic, deconstructed acid-wash denim hoop dress from the collection.

VOSS (S/S 2001)

McQueen's S/S 2001 show Voss was one of his most celebrated theatrical achievements. The centrepiece was an enormous glass box, reflecting the uncomfortably self-aware fashion audience back on themselves as they waited over an hour for the late-running show to begin.

Once illuminated the box was revealed to be a representation

OPPOSITE One of Shaun Leane's metallic bodysuits from McQueen's S/S 2000 collection. Made of a series of silver discs that entirely cover the model's head, the garment was a reference to both the armour of the Crusaders and the face coverings of Middle Eastern women.

of the padded cells of a psychiatric hospital. The models within were unable to see the dimly lit audience – who consequently took on the role of voyeur – as they acted out the part of asylum patients, reaching desperately for their freedom, palms snatching at the glass walls. As model Erin O'Connor recalled to *Vogue* in 2014, McQueen issued the following instructions: "So, you're in a lunatic asylum. I need you to go mental, have a nervous breakdown, die, and then come back to life. And if you can, do that in three minutes and just follow the crescendo of the music."

RIGHT The centrepiece of McQueen's iconic S/S 2001 show Voss was a giant glass box intended to resemble the padded cell of a psychiatric hospital. The models, with their heads bandaged – Kate Moss is pictured here – walked unsteadily around, clawing at the walls.

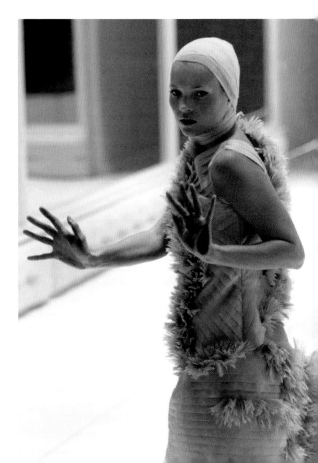

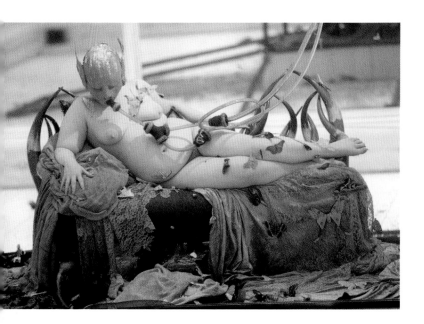

The allusion to the dehumanization of psychiatric patients was enhanced by the fact that the models' hair was covered and their heads were tightly bound by bandages, as if recovering from surgery.

The title Voss came from the name of the Norwegian town famous for its birds and wildlife, and McQueen took much inspiration for the collection from the natural world. The most exquisite and delicate dresses were crafted from razor clam, mussel and oyster shells that McQueen had collected, and the designer's iconic birds were represented in feather-covered skirts and a headdress adorned with stuffed hawks, hovering Hitchcock-like above the model's head as if to pounce. Nevertheless, accents of bloodlike vermilion left onlookers in no doubt as to the medical setting.

McQueen had long examined the concept of bodily

ABOVE For the finale of Voss, the glass box shattered to reveal the naked, voluptuous figure of fetish writer Michelle Olley, in a recreation of Joel-Peter Witkin's 1983 photograph *Sanitarium*. Her face is covered in a horned mask attached to a breathing tube and she is surrounded by flying moths.

OPPOSITE Despite its disturbing premise, the Voss collection featured some of McQueen's most intricate work inspired by the natural world. This black jacket, heavily embroidered with chinoiserie-style birds and flowers, is topped by an extraordinary rectangular headpiece covered in woven, hanging, plant-like fronds.

perfection and was not immune to his own insecurities about his size and shape. The finale of the show posed plenty of unanswered questions about the nature of beauty. As the drama built to a crescendo, and the heartbeat soundtrack ominously flatlined, the glass box shattered to reveal the voluptuous, naked figure of fetish writer Michelle Olley, her face masked and attached to a breathing tube, in a recreation of Joel-Peter Witkin's morbidly obese figure from his 1983 photograph *Sanitarium*. The final, strangely beautiful, touch was hundreds of moths fluttering about her head.

WHAT A MERRY-GO-ROUND (A/W 2001)

This collection for A/W 2001 was McQueen's last to be held at the Gatliff Road warehouse. The set was created around a carousel, but this was no light-filled funfair – rather, a macabre nightmare that cited as references both the 1922 German expressionist vampire film *Nosferatu* and the Child Catcher figure from *Chitty Chitty Bang Bang* (1968). The carousel horses were covered in latex, and models and dancers wearing patent leather and military-style jackets twisted around the poles, bringing to mind darkly sexual Berlin cabaret artists.

The models were disguised by chalk-white Pierrot-style make-up, but the ghoulishness was partly offset by the clothes themselves, which were reminiscent of the roaring 1920s and 1930s, including flapper-style beaded dresses and bias-cut silks. And, for the first time, McQueen's signature motif of the white skull and crossbones appeared on a black knitted dress.

The French Revolution theme – which began with invitations graced by the colours of the Tricolore – echoed through khaki shirts with matching ties, severe greatcoats and gold braid. It culminated in an homage to Eugène

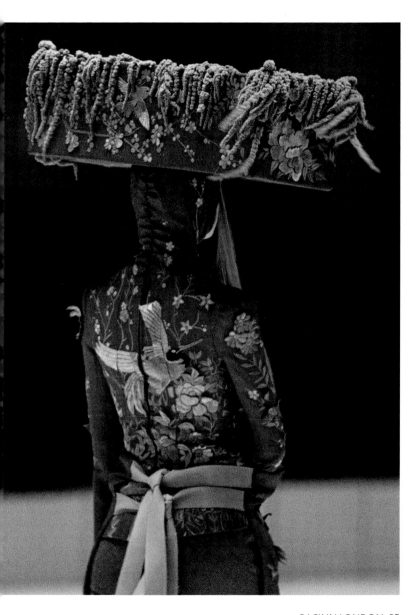

OPPOSITE
McQueen's A/W
2002 show was
a gothic fantasy
inspired by Tim
Burton's films. It also
included a naughty
schoolgirl aesthetic,
as in this outfit
of striped shorts
and matching tie,
a knitted sweater
vest, knee-high
silk stockings and a
Berlin-cabaret-style
jaunty hat. The
make-up is typically
Burton-esque.

Delacroix's 1830 painting *Liberty Leading the People*, the model wearing a bias-cut silver dress, one breast exposed. With his acrimonious relationship to his Paris employers coming to an end, the personal message McQueen was sending was clear – he had freed himself from Givenchy and LVMH.

THE DANCE OF THE TWISTED BULL (S/S 2002)

McQueen's first show since signing a deal with the Gucci Group, who bought a 51% stake in his own company, and also his first eponymous label show to be presented in Paris, was a Latin-inspired fiesta. Deliberately choosing to pare back his trademark theatrics for a new city, McQueen's clothes were still reassuringly flamboyant. It was a solid collection for a designer whose label had recently undergone big changes.

SUPERCALIFRAGILISTICEXPIALIDOCIOUS (A/W 2002)

Named for the cheerful nonsense word from *Mary Poppins* (1964) but shown in the ghoulish Paris prison that held Marie Antoinette before her beheading, McQueen's A/W 2002 show was inspired by gothic film director Tim Burton. Burton also drew illustrations for the invitation which depicted, as described in the *Guardian,* "nightmarish storybook heroines, Frankenstein scars and ragged (but beautifully tailored) dresses".

Burton's drawings set the tone for the show, with its Brothers Grimm fairy tale overtones, complete with a Little Red (or violet, in this case) Riding Hood walking down the catwalk accompanied by wolves.

The collection emphasized a Marie Antoinette tailored hourglass silhouette, complete with corsets (albeit bound with leather straps) and full skirts. There was a slightly risqué schoolgirlish element in the form of blazers and neat, uniform-

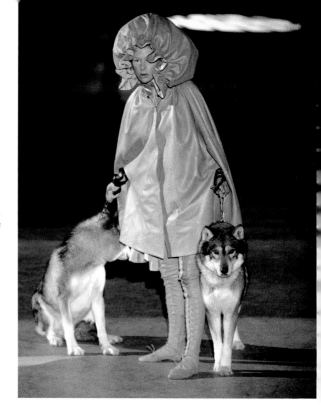

RIGHT The show also included overtones of Grimm's fairytales. McQueen's take on Little Red – or violet, in this case – Riding Hood includes an oversized cape with giant hood and matching laced boots. She is accompanied down the catwalk by two huskies.

like pleated skirts, but the final outfit was the showstopper. Fashion met dark fantasy in the form of black bumster trousers and a billowing parachute silk cloak, topped off by a highwayman's mask and toreador hat designed by Philip Treacy.

IRERE AND SCANNERS (S/S 2003 AND A/W 2003)

McQueen's next two collections, which traversed the globe from the watery tropical islands of the Maldives and Guyana to the wasted frozen tundra of the most northern reaches of Europe, were commercially savvy but lacked the typical trademark theatrics that fashion watchers had come to expect from the designer.

Irere began with drowning maids and evil pirates dressed in brown leather corsets and Elizabethan-inspired knickerbockers, complete with doublets and ruffs. There was a Spanish conquistador feel to a series of black leather cutaway outfits, but then an explosion of tropical colour hit the catwalk. Neon yellow and green dresses in floating chiffon were teamed with matching ruffled capes. Tribal headdresses and a dramatic full-length gown in tiered rainbow layers were – uncharacteristically for a designer who usually danced to his own tune – in keeping with the trends of the season, and all the more wearable for it.

In contrast, McQueen's next show, Scanners, featured a bleak and snow-covered landscape. As he said at the time:

"I wanted it to be like a nomadic journey across the tundra. A big, desolate space, so that nothing would distract from the work."

The collection was reminiscent of McQueen's exquisite couture craftsmanship for Givenchy, with structured suits and hourglass-shaped A-line dresses featuring extraordinarily intricate embellishments. Muted khaki furs and leather were appropriate for the backdrop, but there was also a contrasting accent of bold red in the form of Oriental brocaded kimonos.

DELIVERANCE (S/S 2004)

McQueen's fashion shows were exhaustively researched and every angle carefully considered to achieve the perfect experience. Deliverance was based on the 1969 Sydney Pollack film *They Shoot Horses, Don't They?*, a story of Depression-era contestants who have to literally dance for their lives. The show was staged at the Salle Wagram, a Parisian dance hall built in 1865, and the frenetic pace evoked the exhaustion felt in Pollack's film.

Choreographed by Michael Clark, the show featured models whirled in the arms of muscled sailors, wearing a sparkling extravaganza of glittering dresses with huge feathered skirts adorned in Swarovski crystals. Also on offer were bias-cut 1930s-style silver lamé gowns and corseted pink tulle tutus. Dancers in ballet sweats raced around the stage and, to further emphasize the theme of frenzy followed by exhaustion, the opening dress became the closing piece, but this time, as described in the review from *AnOther* magazine, "the piece was dishevelled and tarnished, worn by a dancer who collapsed at the centre of the stage and was ultimately carried off by Clark and McQueen".

Again, McQueen seemed to be revealing his mixed feelings about the world of fashion – that the glitz and glamour came at a cost.

PANTHEON AD LUCEM (A/W 2004)

Even a designer of McQueen's calibre couldn't hit the mark every time and, amid the gossip about whether he would take over the creative directorship at Yves Saint Laurent (he turned it down), he presented his Pantheon Ad Lucem collection. Meaning "towards the light", the show was intended to strip back McQueen's aesthetic to the essentials, focusing on design rather than theatrics.

The pale-faced models had an other-worldly, androgynous feel to them as they emerged from what appeared to be a spaceship, but there were no flashing lights or stage trickery. Much of the collection was comprised of pale pink and nude jersey and there was minimal adornment. If McQueen intended to simply lay bare his signature styles, including tailoring and an hourglass silhouette, he succeeded, but perhaps at the cost of an impressive show.

OPPOSITE
McQueen's show Deliverance was inspired by the 1969 Sydney Pollack Depression-era film *They Shoot Horses, Don't They?*, in which contestants have to dance for their lives. It was a frenetic show, choreographed by Michael Clark, and full of tailored satin and Swarovski-crystal-embellished outfits.

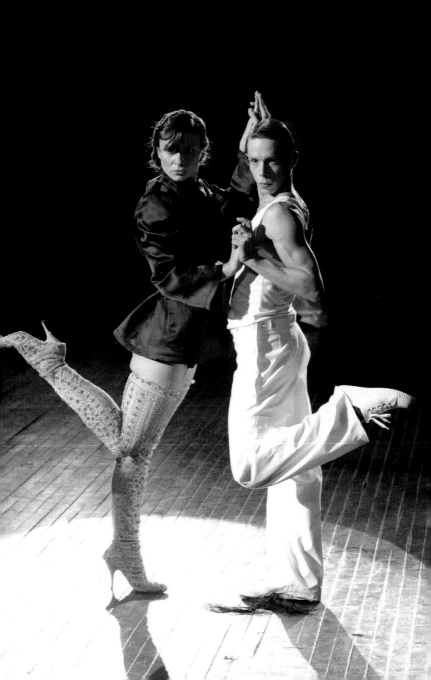

IT'S ONLY A GAME (S/S 2005)

Following on from the somewhat disappointing A/W 2004 collection, McQueen returned to form with one of his most iconic shows. As the models emerged, they took their places on what was soon revealed to be a giant chessboard, and the game began.

In a show choreographed by Les Child, the chess pieces embodied all of McQueen's greatest achievements. As the designer himself admitted in *Vogue*: "It was a lot of McQueen, all in one big collection."

Cinematic inspiration came this time from the 1975 film *Picnic at Hanging Rock*, based on the Australian novel set in 1900 about a group of schoolgirls who disappear. McQueen embodied the girlish Edwardian theme in the shape of fitted blazers, flared short skirts and innocent white lace blouses. He also went back to the eighteenth century, further romanticizing the collection, in a series of empire line floral chiffon dresses and tightly fitted bodices.

The designer's sartorial hits kept on coming, and the chess game – played out to the end – was a mechanism to remind the

BELOW Models lined up in rows for McQueen's show It's Only a Game, for which they took on the form of human chess pieces and proceeded to play out a chess game instead of presenting a traditional show.

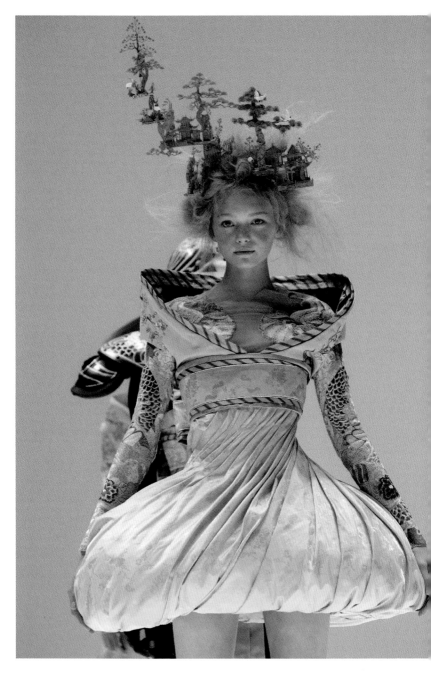

OPPOSITE This outfit embodies all the brilliance of McQueen. The pink dress, embossed with a delicate floral pattern with bolder chinoiserie on the bodice and sleeves, has an eighteenth-century feel, albeit with a perfectly pleated puffball skirt. The model's shoulders are framed by a sculptural, wide-open collar which balances the silhouette, and the candy stripes add a playful edge. The final touch is Philip Treacy's hat, which takes the form of an intricate Chinese garden.

audience of his genius. As Sarah Mower put it, "all McQueen's past signatures and silhouettes were in place: the Savile Row-sharp tail coats; richly embroidered Japanese kimonos; streamlined sci-fi bodysuits; rigid molded corsets; and stiff, flounced godet skirts".

THE MAN WHO KNEW TOO MUCH AND NEPTUNE A/W 2005 AND S/S 2006)

The styling for McQueen's second Hitchcock-inspired show *The Man Who Knew Too Much* – his first, *The Birds* (S/S 1995), was one of his most important early collections – was pure 1960s Hollywood glamour. But rather than channelling the innocent Doris Day, the star of Hitchcock's film, McQueen instead sent models down the catwalk with Tippi Hedren's bouffant hairstyle and Marilyn Monroe's seductive mien. The collection began with the period's iconic nip-waisted tweed suits, pencil skirts and elegant figure-skimming dresses, showcasing McQueen's tailoring and couture skills to maximum advantage.

For loyal clients there were trench coats for daywear and ball gowns for partying, but there was an underlying rock 'n' roll irreverence – and a whole series devoted to leopard print lifted the collection out of the safe zone. And just to cover all bases, McQueen presented a second section, full of Navajo jackets and leather and suede fringing.

With McQueen buckling under the pressure of needing to make sales rather than just headlines, Sarah Mower criticized the designer for presenting what looked like "a merchandise run-through of dubious taste" in her *Vogue* show review.

McQueen's underwhelming performances continued into his next show for S/S 2006, titled Neptune. The distinctly average collection included tailored black suits that lacked McQueen's usual exaggerated silhouette, an uninspiring Greek goddess-

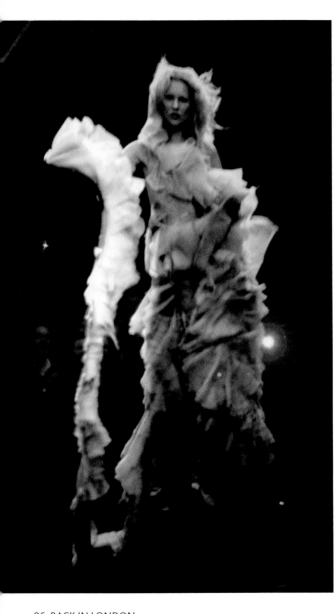

LEFT The mesmerizing finale of Widows of Culloden featured a smoke-shrouded hologram image of Kate Moss. Dreamed up by McQueen and created by video-maker Baillie Walsh, Moss wore a ruffled white dress that billowed around her as she twisted and beckoned to the audience. The atmosphere was heightened by John Williams's soundtrack from the film *Schindler's List*.

OPPOSITE This outfit from Widows of Culloden had a vintage, otherworldly feel. The long, ruffled lace dress with a tiered skirt and long train is covered in appliqué lace flowers and leaves. The finishing touch: a sculptural skull-and-antler headdress swathed in a matching veil.

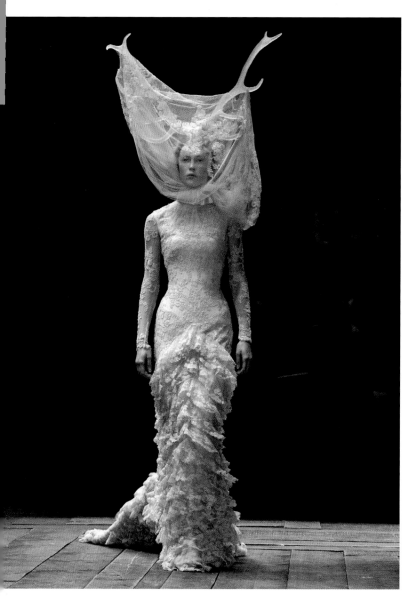

inspired selection and no characteristic showstoppers. Aside from the bold "WE LOVE YOU KATE" T-shirt McQueen himself wore – in support of his friend's drug charge accusation – it was almost as if his spirit had been broken.

WIDOWS OF CULLODEN (A/W 2006)

More than 10 years after his Highland Rape collection confirmed McQueen as one of the most important fashion designers of his generation, the East End designer returned to his preoccupation with his Scottish roots and the oppression of Scotland. This time his inspiration came from the 1745 Battle of Culloden and the forgotten widows of the men who died there.

More importantly, with this show McQueen returned to his theatrical best, silencing the critics who, for the previous two seasons, had questioned his future. The show was dedicated to Isabella Blow, a poignant mention given the ups and downs of the pair's relationship in more recent years, and offered a less rough-and-ready version of many of his Highland Rape creations.

His clan tartan appeared in many guises, including skirts of various lengths, a full trouser suit and a series of dresses, tight at the waist, their skirts puffed out with a Victorian-style crinoline. Heavy knits, oversized furs and feathered ball gowns all evoked a draughty Scottish castle, but there was plenty of gothic romance too. There was even a pre-Raphaelite Lady Macbeth reference. In true McQueen style, the outfits were exquisitely detailed and perfectly executed. Finishing touches included a stunning headdress by Philip Treacy, which Shaun Leane described in the book *Savage Beauty* (2011), noting that the headdress "comprised a bird's nest filled with seven soft blue, speckled eggs encrusted with Swarovski crystals and flanked by mallard's wings".

But the finale took the show to a new level as the empty glass pyramid on the stage filled with smoke that slowly

twisted and turned to reveal a hologram image of Kate Moss, her hair streaming and her white dress billowing around her as she beckoned towards the audience before dissolving away. The other-worldly creation, dreamed up and art directed by McQueen and realized by video-maker Baillie Walsh, was mesmerizing, and made even more extraordinary by the profusion of camera flashes as photographers sought to capture the moment.

LEFT A sketch by Alexander McQueen of the lace dress outfit from Widows of Culloden.

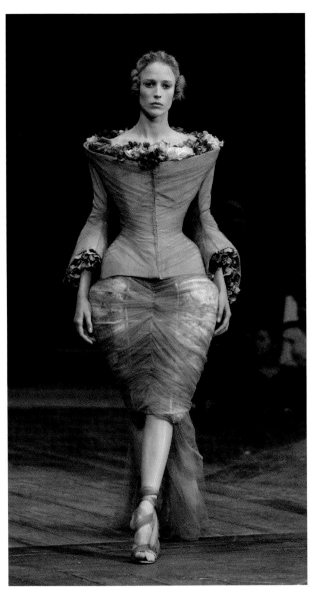

LEFT In this outfit McQueen has emphasized his beloved Edwardian aesthetic by adding voluptuous padded hips to exaggerate the hourglass silhouette. The dusky pink hue of the tailored silk jacket its décolleté filled with flowers, and pleated chiffon skirt and train make for a romantic ensemble.

OPPOSITE Sarabande was one of McQueen's most refined and elegant collections. This corseted dress, covered in appliquéd petals in tones of pink and deep red, has a puffball skirt and narrow belt to emphasize the female form. A glimpse of black lace at the bodice is a touch of sensuality typical of McQueen.

OVERLEAF The outfits, hair and make-up in the A/W 2007 collection In Memory of Elizabeth How, Salem 1692, had an Egyptian feel.

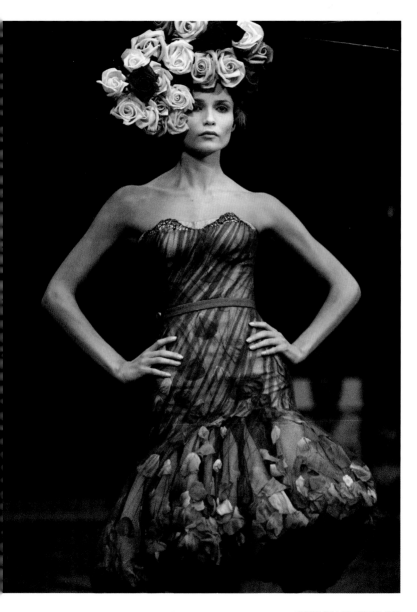

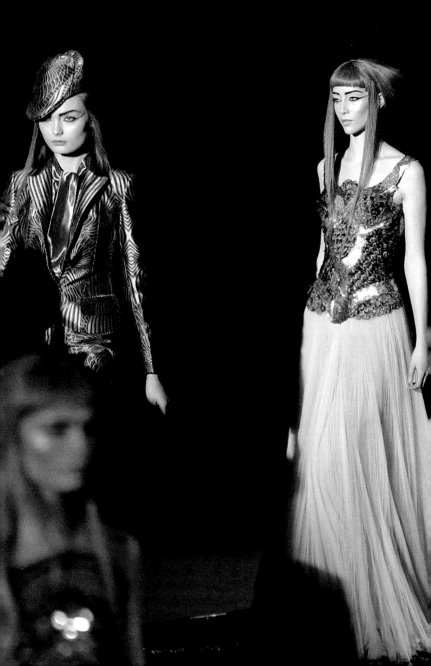

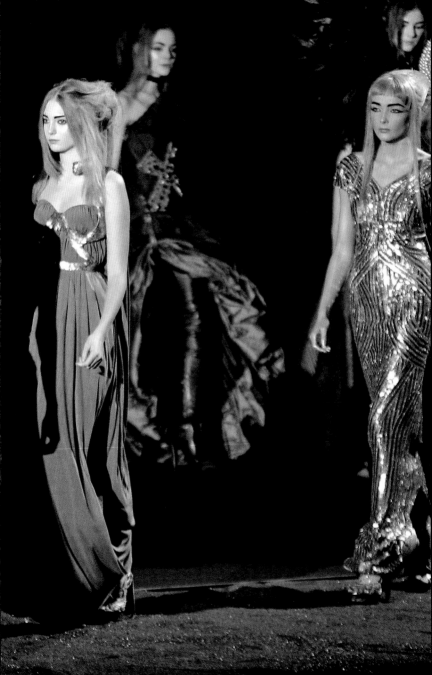

SARABANDE (S/S 2007)

Presented on the circular stage of the grand Cirque d'Hiver in Paris, McQueen's S/S 2007 show cited a range of inspirations, including Stanley Kubrick's 1975 film *Barry Lyndon*; Marchesa Luisa Casati, the decadent Italian heiress born in 1881 whose dark and dramatic appearance saw her compared to a living work of art; and the Spanish artist Goya.

The show saw McQueen turn back to an aesthetic of gothic romance, described in the *Savage Beauty* exhibition catalogue as "fragile beauty undercut with a sense of decaying grandeur".

The melancholy mood was heightened by the models' slow procession to a soundtrack of Handel's baroque musical piece "Sarabande", which was also used by Kubrick in his film.

The collection was planted firmly in McQueen's comfort zone of the nineteenth century and the Edwardian era. The Latin influence came in the shape of flounces and ruffles, black lace and feathers. There was also a slimmer option on offer for the less flamboyant customer in the form of sharply tailored suits and narrow dresses in delicate soft tones of dove grey, faded rose, mauve and antique ivory.

The symbolism of flowers in McQueen's work was evident in the finale showpiece of a chiffon dress, its skirt constructed entirely of fresh roses and hydrangeas as well as silk organza flowers. As the model walked, the flowers began to fall, a poignant comment from McQueen about the transient nature of life. As he told *Harper's Bazaar*: "It was all about decay. I used flowers because they die."

IN MEMORY OF ELIZABETH HOW, SALEM 1692 (A/W 2007)

In one of McQueen's darkest shows to date, he referenced his distant relative, Elizabeth How, who was accused of

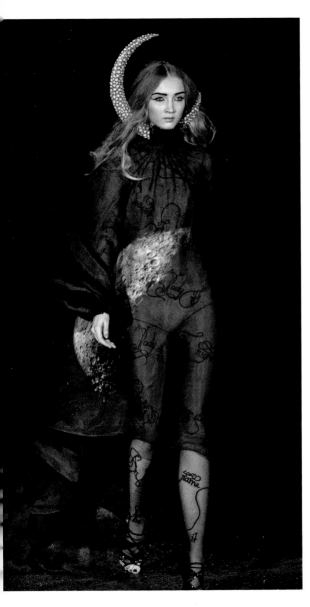

LEFT McQueen's show In Memory of Elizabeth How, *Salem 1692* was one of his darkest. Inspired by his ancestor killed at the Salem Witch Trials, it included outfits such as this sheer black dress with pagan markings, worn with a voluminous black satin cloak and Swarovski-crystal-covered crescent-moon headdress by Shaun Leane.

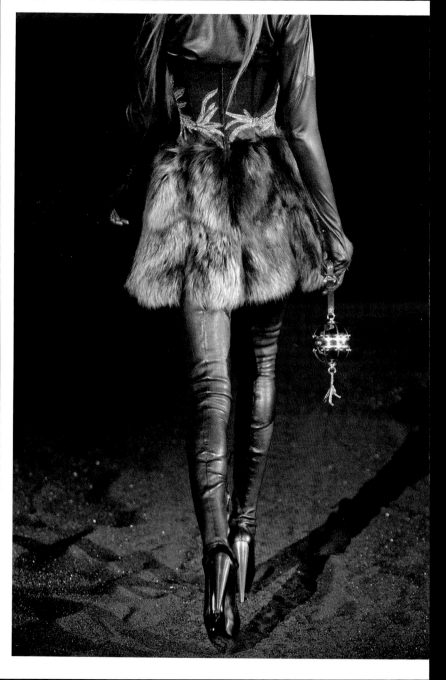

OPPOSITE Every detail was carefully thought-out and meticulously crafted by McQueen. The crystal-embellished motif on the leather corset echoes the bird claw hanging from a chain on the model's orb bag. The fur trim alludes to the hunt.

being a witch and hanged at the famous trials held in Salem, Massachusetts, in 1692. The set comprised a huge inverted black pyramid hanging from the ceiling and a black-sand-covered runway depicting a similarly oppressive red crystal pentagram, a reference to Egyptian paganism. McQueen included headdresses by Shaun Leane which were covered in Swarovski crystals and featured the crescent moon and stars – pagan symbols of female moon-goddess rites – as well as gothic crosses and tribal markings on his designs.

The show opened with disturbing images typical of McQueen's shock tactics playing above the model's heads, described in *Vogue* as "a macabre film – of naked women, swarming locusts, faces decaying to skulls, and blood and fire".

However, the clothes were more about changing silhouettes as McQueen abandoned his traditional corseted hourglass. Similar to the outfits in Sarabande, there were voluminous padded hips, and the designer continued to experiment with spherical shapes. But there were also trailing gowns, both empire-line and fishtail, in hues of green and gold, along with black and silver eveningwear.

McQueen's intended message was to condemn bigotry, epitomized so dramatically by the unjust killing of his ancestor Elizabeth How. But instead, he was yet again accused of hating women, with *Women's Wear Daily* going so far as to call the show "a study in vitriol expressed via fashion".

In her book *Alexander McQueen: Fashion Visionary*, Judith Watt defended McQueen: "Not so, this was a response to the outrage of what had happened to innocent women, not the corrosive vision of a poisoned mind."

LA DAME BLEUE (S/S 2008)

McQueen's S/S 2008 show came less than six months after the tragic suicide of Isabella Blow, patron, muse and, above all,

OPPOSITE *La Dame Bleue* was McQueen's tribute to the late Isabella Blow. It celebrated her love of bold outfits, nature and their shared passion, birds. This jubilant rainbow-coloured pleated chiffon dress, modelled on a bird of paradise, explodes around the neckline into a halo of feathers.

friend to McQueen. The show was a tribute to Blow in all her eccentricity, especially celebrating her love of his most exuberant outfits.

Ironically, given McQueen's own suicide just a few years later, he seemed phlegmatic at the time, telling *W* magazine in his first interview since her death: "I learned a lot from her death, I learned a lot about myself … that life is worth living. Because I'm just fighting against it, fighting against the establishment. She loved fashion, and I love fashion, and I was just in denial."

Like McQueen, Isabella Blow loved birds and nature and they had a mutual passion for falconry. The collection reflected this with feathers, both printed and delicately painted as part of a mask, and bird and butterfly motifs, including joyful rainbow coloured tropical birds of paradise. Blow was also a lifetime devotee of Philip Treacy's hats and one of the few people who got away with wearing some of his most outrageous designs. The milliner outdid himself with his own homage to the late stylist by creating an extravaganza of headpieces, including a flock of red butterflies made from feathers and twisted dragonflies perched on the front of a model's head.

The show also showcased variations on many of McQueen's greatest achievements from previous collections, highlighting his impeccable Savile Row tailoring and moulded-dress silhouette. It seemed that McQueen was pushing through his grief and cementing all that made him a great fashion designer. *Vogue's* show review summed it up: "In all, McQueen honored his mentor by striving to bring out the best in himself."

THE GIRL WHO LIVED IN THE TREE (A/W 2008)

After Isabella's Blow's funeral and the success of La Dame Bleue, McQueen and his long-time collaborator, jewellery designer Shaun Leane, travelled to India for a month, a trip he later called a "pilgrimage". McQueen returned not only as

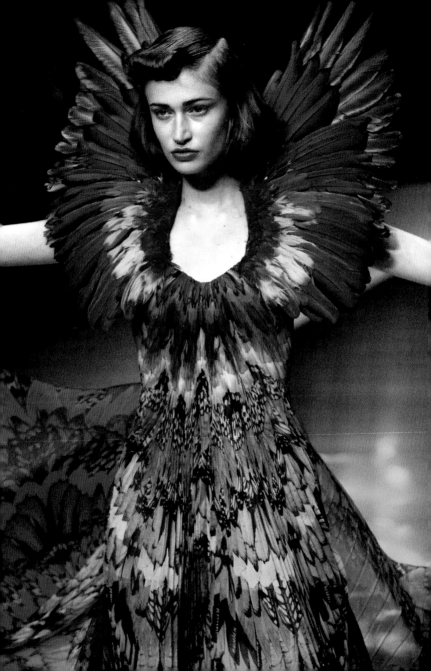

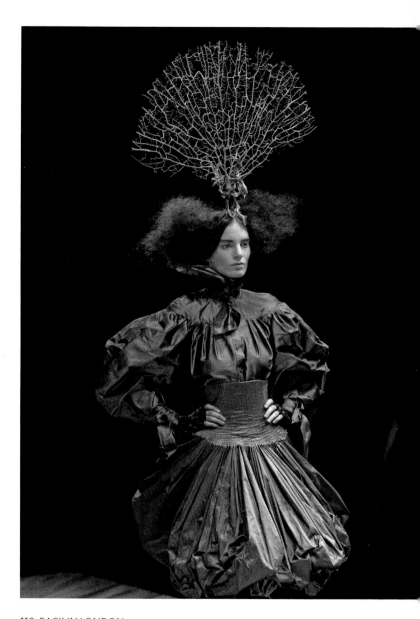

OPPOSITE In
onour of the title
f McQueen's show,
he Girl Who Lived
n the Tree, Philip
reacy created one
f his extraordinary
culptural
eadpieces. The
rystal-laden
ree is set off by
n androgynous
lizabethan-style
lack gown.

a converted Buddhist but also with a new appreciation of the aesthetics of the British Empire and grand days of the Raj. This was reflected in his next collection by gold-edged regimental-style jackets and ermine-trimmed regal gowns. The dress silhouettes also echoed the grand days of British haute couture, in particular the work of Hardy Amies and Norman Hartnell, both favourites of the young Queen Elizabeth II.

The title of the show came to McQueen as he contemplated a 600-year-old elm tree in his Sussex garden, imagining a girl he described as a "feral creature" who lived within it. He elaborated prior to the show: "I made up this story of a girl who lives in it and comes out of the darkness to meet a prince and become a queen."

And so, the regal collection presented a series of exquisite dresses with tightly fitted bodices and net-stiffened ballerina skirts – W magazine called them "Victorian Goth ballerinas" – covered in Swarovski crystals or intricately woven with lace. It was an unusually feminine collection and, perhaps coincidentally, it was also the first time that the McQueen label started turning a profit.

NATURAL DIS-TINCTION, UN-NATURAL SELECTION (S/S 2009)

For all his strong opinions, Alexander McQueen would not normally have been pegged as an environmental activist and yet, in his S/S 2009 show, that was the message that he sent. The show followed the journey from Darwin's evolution through the Industrial Revolution, to finally condemn humanity's devastating effect on the natural world.

The set featured a metal globe, onto which was projected a revolving Earth, Sun and Moon, and the edges of the catwalk were lined with examples of Victorian taxidermy to represent endangered species such the elephant, giraffe, polar bear and lion.

The clothes themselves were initially representative of the purity of the natural world before humans interfered. Natural fibres, delicate chiffon shift dresses with flowers trapped in a translucent mesh were juxtaposed with a series of tailored frock coats, slim trousers and dresses made from fabric printed with the shapes of wood.

Later in the collection the atmosphere darkened. The shapes and patterns of the clothes were now made from either black or unnaturally coloured synthetic fabrics, and became harsher, evoking industrial shapes and buildings. The use of Swarovski crystals wasn't glamorous here but overly bright and unyielding, in marked contrast to the softness of the natural world.

In the show notes, which featured the image of McQueen's face morphing into a human skull, the designer wrote: "We're in danger of killing the planet through greed."

THE HORN OF PLENTY (A/W 2009)

This was the last full A/W collection McQueen would design before he died by suicide in 2010. With hindsight, the disillusionment he felt with the fashion industry was clear. The show, dedicated to his mother, was intended as a comment on the inherently disposable nature of fashion. It was a prescient attitude, expressed several years before the backlash against fast fashion became such a vocalized topic.

As he told the *New York Times* before the show: "This whole situation is such a cliché. The turnover of fashion is just so quick and so throwaway, and I think that is a big part of the problem. There is no longevity."

The atmosphere was one of despair and destruction. The runway was made of shattered mirrors and a giant tip was filled with discarded household rubbish, as well as props from several of his own past shows. Sartorially, it was both

OPPOSITE McQueen always sent a message with his collections, and in later years this became about environmental protection. This bright yellow minidress from Natural Dis-Tinction, Un-Natural Selection (S/S 2009) is encrusted with three-dimensional sequinned flowers and delicate appliquéd daisies on a mesh body with a zip detail on the forearms.

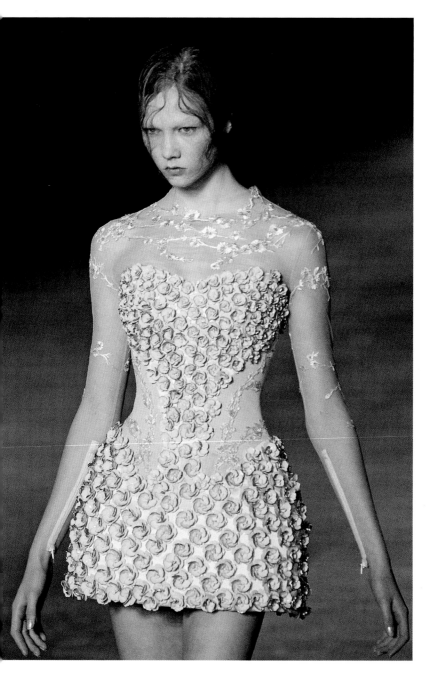

LEFT McQueen became increasingly disillusioned with the fashion industry and his A/W 2009 show The Horn of Plenty criticized the fast-fashion mentality. Models with pale faces and hypersexual, oversized red lips wore outfits that mocked the fashion greats, including Christian Dior and Coco Chanel, who were renowned for their tweeds and black and white houndstooth checks

a retrospective of McQueen's own work over the previous 15 years and a tongue-in-cheek comment on the legendary fashion designers of the past.

White-faced models with ghoulish, oversized red lips, Leigh Bowery-style, paraded in houndstooth and tweed, parodying the neat suits of Chanel and Dior's iconic New Look dresses. Their headpieces were created from debris, such as aluminium cans wrapped in plastic, and parts of other outfits were made from bin bags. McQueen was clearly not willing to throw everything away just yet, and the collection also included a run-through of his greatest hits, making sure that it had a commercial chance despite the designer's cynicism about the state of fashion.

It is interesting to note that the name The Horn of Plenty referenced the pub in which Jack the Ripper's last victim, Mary Jane Kelly, was sighted, a neat way of taking the collection full circle back to McQueen's first ever show.

PLATO'S ATLANTIS (S/S 2010)

McQueen's final catwalk show foreshadowed the uber-tech world of fashion live-streaming that would become the norm in the years after his death. Those who were lucky enough to be in attendance were treated to one of McQueen's greatest collections, set in the mythical underwater world of Atlantis. The inspiration was the story told by the Ancient Greek philosopher Plato of the utopian island that sank into the sea, which McQueen saw as analogous to our own destruction of the planet.

The *Savage Beauty* exhibition explained how McQueen envisioned the Atlantis myth as an apocalyptic future for humankind, in which Darwin's theory of evolution happened in reverse: "The ice cap would melt, the waters would rise and life on earth would have to evolve in order to live beneath sea

once more or perish. Humanity would go back to the place from whence it came."

For his collection this translated into a series of minidresses featuring digitally engineered three-dimensional prints of sea creatures, in shades of aqua, green and brown. They were worn by other-worldly models with hair moulded into finlike shapes and with make-up that made them appear reptilian. The final touch came from McQueen's towering "Armadillo" boots. As Sarah Mower phrased it, "It looked as if McQueen was envisaging a biological hybridization of women with sea mammals."

McQueen offered his audience a taste of the future in both the technological staging of the show and the collection itself. But more than that, the taxi driver's son from the East End proved himself to be a philosopher as well as a fashion designer, which made his sudden and untimely death all the more tragic.

ANGELS AND DEMONS (A/W 2010)

On 11 February 2010, the day before his beloved mother Joyce's funeral, Alexander Lee McQueen took his own life. An inquest later found that he "killed himself while the balance of his mind was disturbed".

The Gucci Group immediately confirmed that they would still support the label and that the scheduled A/W 2010 show on which McQueen had been working would go ahead. Under the guidance of Sarah Burton, McQueen's head of womenswear for over a decade, the 16 pieces that he had planned were completed and shown to a small, private audience.

Unlike Plato's Atlantis, which was a portrayal of a cataclysmic future, this collection looked back to the past, both at McQueen's previous collections and at the religious

OPPOSITE
McQueen's final catwalk show was inspired by Plato's mythical underwater city of Atlantis. The models' hair – moulded into fin-like shapes – and amphibian make-up were intended to show Darwin's evolution in reverse in a mythical city where humans returned to the sea.

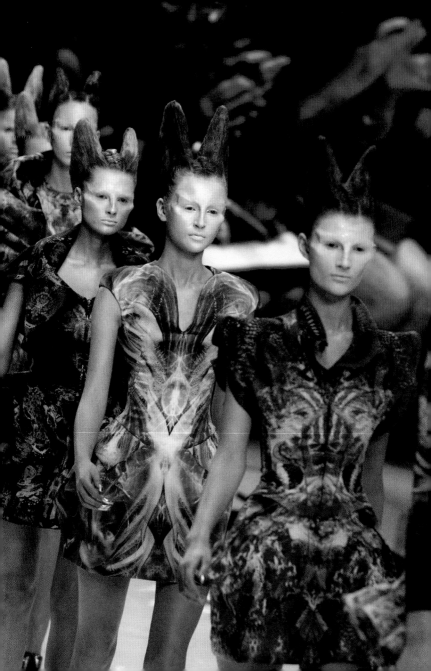

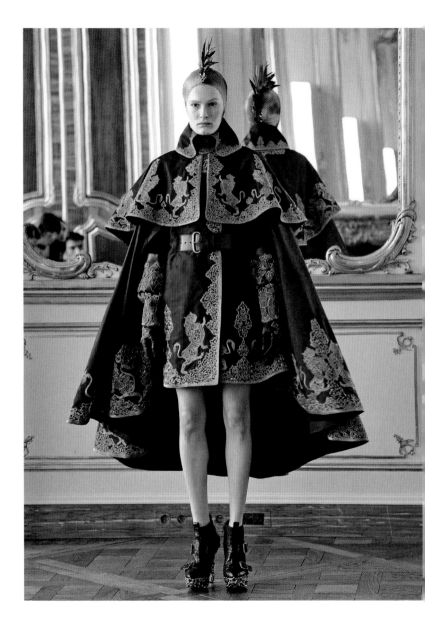

conography of the medieval period which had long inspired him. Sadly, McQueen had appeared to be going back to his tailoring and couture basics, to rebuild a fashion label of which he could be truly proud.

As Burton told *Vogue*: "He wanted to get back to the handcraft he loved, and the things that are being lost in the making of fashion. He was looking at the art of the Dark Ages, but finding light and beauty in it. He was coming in every day, draping and cutting pieces on the stand."

The collection was a poignant one, not only because of its melancholy, historic tones, but also for the jolt that a reincarnation of an outfit from his first gold-winged show for Givenchy gave the audience. It was a reminder both of the vision that McQueen had possessed and of the singular talent that the fashion world had lost.

OPPOSITE McQueen's posthumous collection consisted of just 16 outfits, finished by Sarah Burton. He had returned to earlier themes, including the medieval era and religious iconography, and had renewed his emphasis on meticulous tailoring. This regal black and gold coat dress and cape is lavishly embroidered with heraldic motifs.

LEFT Lee Alexander McQueen died on 11 February 2010. During London Fashion Week just days later, a memorial wall illustrated how much the designer had meant to so many people.

COLLABORATORS
AND MUSES

A DREAM TEAM

*"He was like an artist presenting a dream,
a story, a performance."*
KATY ENGLAND

COLLABORATORS

Simon Ungless

When he was a new student at Central Saint Martins, McQueen befriended Simon Ungless, a textile designer with whom he formed a creative partnership. Ungless was the son of a gamekeeper and shared McQueen's passion for nature, birds and collecting tactile curiosities.

Ungless was McQueen's first major collaborator and designed many of his iconic early prints – for example, the tyre-track and swallow patterns in The Birds. He also contributed significantly to McQueen's landmark Dante show, famously using – unfortunately without permission, which meant the

OPPOSITE Simon Ungless created some of the most recognizable of McQueen's early prints. This graphic black thorn print from The Hunger (S/S 1996) is a typical example of his delicate interpretation of nature.

clothes later had to be destroyed – Don McCullin's Vietnam War images to screen-print onto fabric.

Ungless moved to California in 1996, but he recalled his part in McQueen's early designs to *Marin Living* magazine in 2021: "I believe the Dante collection took McQueen to a new level of design and I'm still very proud to have been part of it. I have one secret piece from the collection; it truly is my most valued possession."

Isabella Blow

Isabella Blow was McQueen's mentor, patron and muse. They had an almost familial relationship, which was both extremely close but somewhat volatile. As McQueen's sister Janet explained it in an interview with Lauren Milligan in 2015: "I always put Isabella between my mum and his sisters. She was sort of in the middle, a peg down from Mum."

The eccentric stylist, who, according to the *Daily Mail*, McQueen once described as "a cross between a Billingsgate fishwife and Lucrezia Borgia", spotted the designer at his Central Saint Martins degree show. She famously paid £5,000 for the entire collection.

Though McQueen was initially sceptical about Blow and found it hard to relate to her upper-class background and flamboyant behaviour, she clearly had an unerring eye for spotting genius. As Anna Wintour once said: "When Issie told me to go and see somebody, or to take somebody seriously, I always did."

Over the early years of his career, Blow had a great deal of influence over McQueen both socially and stylistically. McQueen used her Chelsea house as a studio and her country home as a location for fashion editorials. Blow also walked in his 1994 show Banshee, famously appearing with the word "McQueen" stencilled in silver onto her head.

LEFT Isabella Blow was instrumental in launching McQueen's career, which began when she bought his graduate collection. She was his muse, patron and biggest cheerleader, especially in the early days. Blow is pictured here in typically eccentric dress with McQueen in 2003.

In an interview with *The Cut*, milliner Philip Treacy remembers her indefatigable belief in McQueen: "Isabella was his defender. It's easy for everybody to love him now, but she was cheerleading him for years and years and years."

When McQueen accepted his role at Givenchy, their relationship became more strained. Blow believed she had pulled strings to get him the position and assumed she would be offered a paid role alongside him at the grand fashion house, but she was not.

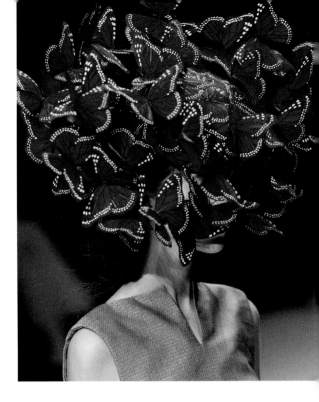

RIGHT Philip Treacy had been as close to Isabella Blow as McQueen had, and felt similarly moved to pay tribute to the late stylist in the form of a feathered headpiece made to look like a flock of red butterflies.

Her husband Detmar later criticized McQueen in his biography of his late wife, *Blow by Blow* (2010): "I did put the boot into Alexander. I think he bloody well deserved it. He let Issie down. There's no two ways about it."

Although the pair drifted apart in later years, partly as a result of Blow's ongoing mental health issues and frequent suicide attempts, her death in 2007 inevitably affected McQueen, and he dedicated his S/S 2008 show La Dame Bleue to her memory.

In September 2009 he told the *New York Times:* "She would say that fashion killed her, but she also allowed that to happen in a lot of ways. She got herself some good jobs and she let some

of them go. You could sit Isabella down and tell her what she should do with her life. But she would never understand that all it came down to [was], 'You just are, Isabella. And that is your commodity.'"

Katy England

Another stylist who had a similarly big impact on McQueen's aesthetic was Katy England. McQueen first spotted her wearing a nurse's uniform and was intrigued, so when he later bumped into her in a Soho trimmings store, he invited her to chat. England recalled to the *Guardian* in 2013: "He came over and said: 'Are you Katy England? Do you want to go for a cup of tea?'"

They immediately hit it off. England said in a 2015 interview with SHOWstudio.com: "I was instantly attracted to him; he was a really charismatic guy."

She agreed to style his third catwalk show, The Birds, coming up with the brilliant idea to roll a muddied tyre over models' naked skin to resemble car tracks. This willingness to experiment led to some controversial press, but as she later explained: "We didn't really care. It was an amazing feeling … I can remember real negativity around him, being too aggressive. He did grow up, of course – those were the early days. As the years went by, he softened."

McQueen had strong opinions about the concept of bodily perfection within the fashion world, and he and England were pioneers in breaking boundaries around discrimination. McQueen guest-edited the forty-sixth issue of *Dazed & Confused* magazine in 1998, which was styled by England. It focused on disability and included an editorial story featuring the double amputee model Aimee Mullins wearing prosthetics. Shot by photographer Nick Knight, with whom McQueen also collaborated on many occasions, it was an early challenge to

the ableism that was then endemic in the world of high fashion. McQueen went on to use Mullins in several of his catwalk shows, most notably his No. 13 collection, which featured the model wearing a pair of intricately carved wooden legs.

Acting variously as stylist, muse and fit model, England was a major collaborator of McQueen's for more than a decade and was instrumental in bringing to life many of his most dramatic catwalk shows.

Simon Costin

McQueen depended on the artist Simon Costin, who had trained as a theatre designer, to both source and design props, and art direct his increasingly ambitious shows.

Like McQueen, Costin was deeply interested in the more macabre aspects of history. In the 1980s he had designed shocking pieces, such as his "Incubus" necklace, which included vials of human semen and was inspired by nineteenth-century collectors. As Costin admitted to *i-D* magazine in 2014, "I am quite dark … which is why I think I worked with Alexander McQueen so well."

Costin was also similar to McQueen in that he was an uninhibited visionary, telling the *Financial Times* in 2015: "I like storytelling and magic, I like to create a whole world."

Like most of McQueen's collaborators, Costin was also a good friend, and fellow clubber, before the pair worked together for the first time on The Birds. Costin also worked on the notorious Highland Rape show, and for Dante he made bird claw jewellery and a widow's peak headdress in black jet.

When designing McQueen's shows, Costin described the process as "very organic". Costin's creativeness allowed him to realize McQueen's fantasies using a range of imaginative techniques and props, often on a tight budget, and he reminisced in the same interview about how "cobbled together it was".

One of Costin's final, but most memorable, creations was for McQueen's S/S 1998 show, Untitled. It featured a runway of Perspex water tanks, the liquid in them initially clear until the audience watched, mesmerized, as black ink seeped into the water, turning it darkly opaque, in a yin-yang moment halfway through the show.

Shaun Leane

Shaun Leane began his apprenticeship as a jeweller in London's Hatton Garden at the age of 16, just as McQueen had done on Savile Row. He first worked with McQueen on the Highland Rape collection and, over their 17-year collaboration, Leane

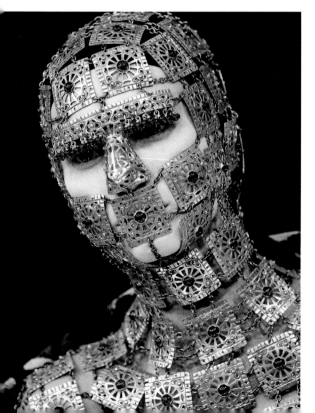

LEFT This piece by Shaun Leane was created from interlinked and bejewelled metal plates. It was originally designed as a type of yashmak for The Eye in 2000, but was reworked later as a mask and breastplate for McQueen's A/W 2009 collection, The Horn of Plenty.

BELOW A headpiece
of flying planes
by Philip Treacy
for McQueen's
Widows of Culloden
collection.

created not only pieces of jewellery but also whole moulded garments for McQueen.

He is quoted by the Victoria and Albert Museum explaining how much McQueen pushed him: "Lee took me out of the zone of making jewellery that has to be earrings or necklaces or bracelets or tiaras, to actually creating pieces from a metal form that became part of the garment. Or became the garments themselves."

Leane's most notable work included the religion-inspired "Crown of Thorns" headpiece he created for Dante, tribal-style pieces modelled on ringed necklaces, and several coiled corsets

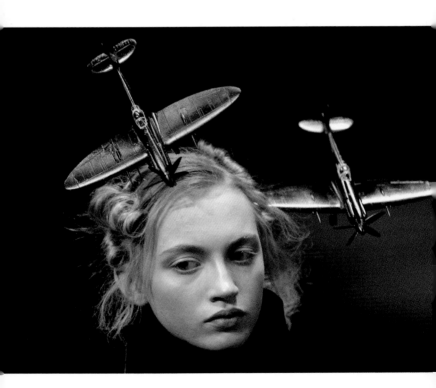

such as the one for The Overlook, the label's A/W 1999 collection, on which he reportedly worked 16 hours a day for 10 weeks.

Philip Treacy

In tandem with the jewellery of Shaun Leane, Philip Treacy's headdresses were essential in elevating McQueen's outfits to new levels of wonder. Described by *Vogue* as "perhaps the greatest living milliner", Treacy was another protégé of Isabella Blow, who had invited him to make a hat for her wedding in 1999. It was the first in a long line of Treacy's wonderfully eccentric creations to grace Blow's head.

Despite the fact that the impact of McQueen's outfits often relied heavily on Treacy's dramatic headpieces, the designer didn't brief him directly, instead using stylist Katy England as an intermediary.

As he explained to *Hero* magazine in 2021: "[Katy] was the mood-board … his idea of a brief was something you've never seen before, which of course was never easy, but we like that kind of a challenge. He was interested in originality, and so am I. With McQueen, he wouldn't see the hats until about an hour before the show … Basically if he didn't like it at that point, I was fucked!"

But Treacy's level of imaginative genius and technical skill didn't disappoint. His most iconic creations included many permutations on the theme of stuffed birds and feathers, such as a whole bird's nest of crystal-studded turquoise eggs complete with falcon wings, as well as horns and other references from the animal kingdom.

More sculptural pieces were the intricate "Chinese Garden" for It's Only a Game (S/S 2005); a moulded, wimple-like white hat for The Horn of Plenty; and, of course, the triumphant explosion of red feather butterflies from Treacy and McQueen's tribute show to Isabella Blow, La Dame Bleue.

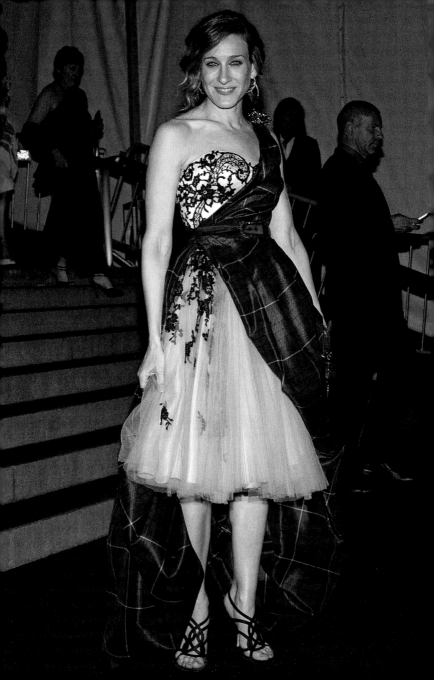

RIGHT David Bowie photographed in 2000 wearing a printed silk coat by Alexander McQueen.

OPPOSITE Sarah Jessica Parker wearing classic McQueen to the Anglomania ball at the Metropolitan Museum of Art in 2006. She sports a pleated ballerina-style net dress with black lace appliqué, topped by a one-shoulder clan tartan over-gown secured at the waist by a narrow belt. She wears a bejewelled Scottish thistle pin on her shoulder.

MUSES

Alexander McQueen was London's most talented and charismatic designer and, perhaps thanks to his "bad boy" image, caught the attention of a number of socialites and celebrities. Along with Isabella Blow, several other upper-class women became friends and muses of the designer, most notably Annabelle Neilson and Daphne Guinness.

Annabelle Neilson

Annabelle Neilson was introduced to McQueen by Blow in 1993 and quickly became a close friend, ally and muse of the designer, staying in his home and frequently appearing on the catwalk in his creations. Neilson called him her "soulmate", explaining: "However odd we may have been to those who looked at us – we worked. East End gay boy meets skinny English posh bird with a naughty streak."

McQueen often designed using Nielson as a model, sketching and even cutting garments while they were on still her body, which could be a nerve-racking experience: "I never quite felt comfortable with the way he would cut clothes with me in them, the scissors a skin cell away from a permanent scar."

Neilson inspired many of his iconic collections, including Joan, which he dedicated to her, and The Girl Who Lived in the Tree, which was partly inspired by a fairy-tale-like story Neilson wrote.

Daphne Guinness

Daphne Guinness, heir to the Irish brewery fortune and granddaughter of Diana Mitford, was another aristocratic socialite who counted McQueen as one of her close friends. Like Isabella Blow, she wore McQueen's clothes as often as possible and her elfin figure and sculptural looks set off his baroque creations to perfection.

OPPOSITE Socialite Daphne Guinness, McQueen's friend and muse, attending the opening of the McQueen retrospective, *Savage Beauty*, at the Metropolitan Museum of Art in 2011. She is wearing a swanlike, white feathered ball gown from the McQueen Spring 2011 collection.

LEFT Lady Gaga, pictured accepting a Bambi Award in 2011, wearing a gown from the Alexander McQueen S/S 2012 collection. The heavily beaded cutaway gold bodice extends into a skull cap and is offset by a fishtail skirt made from a cloud of ruched and pleated chiffon.

However, they nearly didn't meet. Guinness, though she admired McQueen's work, hated the idea of becoming one of his groupies. She told *W* magazine that it was McQueen who made the first move:

"One day, he saw me walking across the street in his kimono and he ran up to me and said, 'I'm the person you don't want to meet!' We went to a pub and hit it off. Of course after that I was so irritated not to have known him before!"

Lady Gaga

Lady Gaga was also a huge fan of McQueen's designs, which suited her outlandish aesthetic perfectly. Aside from Daphne Guinness she was one of the few who happily wore his 7-inch Armadillo shoes and, in the years before his death, the singer had become an unofficial muse to the designer. She even dedicated the song 'Fashion of His Love', on her 2011 album, *Born This Way*, to McQueen. Lady Gaga remains a big fan of the Alexander McQueen label to this day.

Supermodels

Various supermodels, such as Stella Tennant – another Isabella Blow discovery – became favourites of McQueen, although many were not well known when they started walking for him. Gisele Bündchen made her international debut in McQueen's S/S 1998 show, although she nearly refused, as she was asked to appear topless. It was only the intervention of a resourceful make-up artist, who painted an opaque white top onto her body, that encouraged her to go on.

Perhaps the one supermodel who could truly be called a muse to McQueen is Kate Moss. Moss was also a close friend of the designer and a regular in his early shows. But her most memorable appearance, as an ethereal hologram, was for the finale of Widows of Culloden, his A/W 2006 show.

As a tribute to McQueen after his death, Moss appeared on the cover of the May 2011 issue of *Harper's Bazaar* modelling the very same dress, telling the *Daily Mail*: "He was a dear friend of mine … There was so much tension, but we had the best laughs. I miss him terribly. He gave women power, while letting them be fragile and vulnerable at the same time."

RIGHT Kate Moss was a friend and muse of Alexander McQueen since her debut at the New York showing of his 1996 Dante Collection. She wore his iconic bumster trousers and a top with Don McCullin's war photo of an elderly Vietnamese man.

OPPOSITE Model Naomi Campbell was a long-time friend to Alexander McQueen who also became involved with his charitable Sarabande Foundation after his death. She is pictured here on a rare return to the catwalk for Sarah Burton's S/S 2022 show.

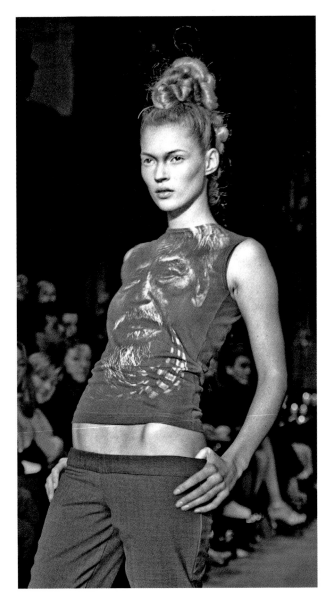

SARAH BURTON:
BEYOND
McQUEEN

KEEPING McQUEEN'S LEGACY ALIVE

"He was so inspiring. He was very kind to me. He was like a big brother. I was very shy, came from a very different background, but because Lee believed in me, it made me believe in myself."
SARAH BURTON

Sarah Burton first arrived at Alexander McQueen in 1996 for a work placement as part of her degree at Central Saint Martins. She returned to McQueen straight after graduating, and in 2000 was made head of womenswear. She was, in every way, his right-hand woman.

Sarah Mower described Burton's role when she interviewed the designer for *Vogue* in 2018: "Burton became the person who assisted him in conjuring up any seemingly impossible creative solution." Burton agreed: "I was a pillar; my job was to make things happen."

It was inevitable that when McQueen died suddenly in 2010, Burton would take over the reins. Her most pressing task was to finish his collection Angels and Demons, which she did with

OPPOSITE Sarah Burton, in an elegant, Grecian-style gown, attends the opening of Alexander McQueen: *Savage Beauty* at the Costume Institute Gala at the Metropolitan Museum of Art in May 2011.

OPPOSITE
Kate Middleton
wearing an Alexander
McQueen wedding
gown designed by
Sarah Burton for
her marriage to
Prince William in
April 2011. The ivory
silk tulle dress was
covered in handmade
lace appliqué and
hand-cut lace
flowers traditional
to the British Isles,
such as roses,
thistle, daffodils
and shamrocks.
The bodice, which
was inspired by
Victorian corsetry, a
longtime signature
of McQueen, was
made from Chantilly
lace. The dress was
completed by a two-
metre-long train.

the utmost sensitivity and skill. She executed it perfectly and explained to audiences that McQueen's intention with this collection was to return to the bare bones of his craft. It was a small and poignant presentation, allowing the fashion world to reflect on the passing of a singular talent.

But the show had to go on, and Burton's impeccable stewardship of the Alexander McQueen label was widely acknowledged when she presented her first solo collection six months later. As *Vogue* commented: "Sarah Burton is precisely the kind of quiet powerhouse who has what it takes to grab hold of his legacy and drag it where it needs to go to survive and prosper."

McQueen had left behind so many of his creative ideas – all well known to Burton, who had worked so closely alongside him – that her collection was certainly equal to one he might have designed. The one difference was in the staging of the show, which was less dark and theatrical than before. There were already murmurings that Burton would bring a softer, more feminine touch to the sometimes aggressive McQueen rhetoric.

Burton seems a less troubled character than McQueen was, or perhaps just a more private one, and as such has used fewer autobiographical themes in her collections. As Hamish Bowles, global editor of *Vogue*, put it in 2017:

> *"Where McQueen drew on history and technology to explore his inner demons and reflect his often disquieting vision of a dystopian world, Burton uses those same themes and resources to celebrate her passion for traditions and craftsmanship, and the ways they can be harnessed to flatter a woman."*

One area of inspiration which Burton has in common with her late mentor is the natural world, and she initially looked

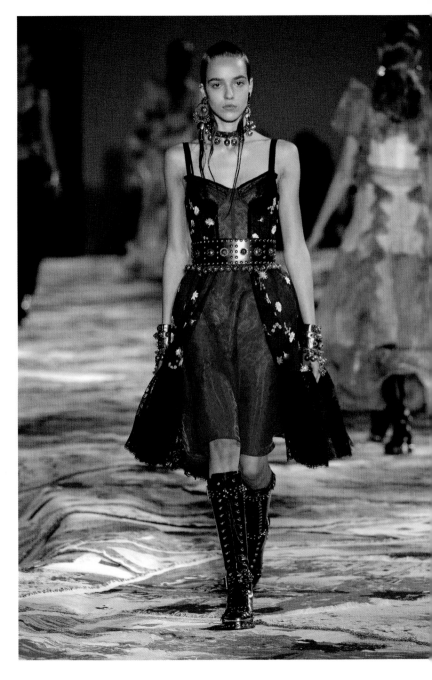

OPPOSITE Sarah
Burton's S/S 2017
collection for
Alexander McQueen
took its inspiration
from the Shetland
Islands and was
reminiscent of
McQueen's own
preoccupation with
Scotland. This semi-
corseted, double-
layer red and black
silk organza dress is
appliquéd with wild
flowers. Its delicacy
contrasts with the
wide belt, studded
and trimmed with
bells, and high
boots which have an
armoured, medieval
feel.

to the English countryside of her youth to heal the loss of
McQueen. Her debut collection included a dress covered in
the wings of monarch butterflies, and gowns featuring stalks
of corn and pheasant feathers – all in the rich colours and
eighteenth-century silhouettes to which McQueen himself was
so drawn. Notably, the craftsmanship was as impeccable as
anything McQueen himself had sent down the catwalk.

Burton has kept McQueen's trusted team, led by head
atelier Judy Halil, who has been with the brand since 1997,
and still uses Russian fit model Polina Kasina. She works
collaboratively with her design team to spark ideas that
eventually coalesce into a story that will become a collection.
Her creative process is as organic as McQueen's was.

Burton's collections over the decade she has been creative
director at McQueen have very much kept to the label's
heritage, with plenty of historical references, natural elements
and exquisite tailoring. She has even known when to add a little
darkness – for example, a series of black leather and masked
models breaking up her romantic, feminine chiffon dresses for
S/S 2012. As Tim Blanks pointed out in his show review for
Vogue:

"This collection proved how hot-wired into the core of
McQueen Burton truly is … She'll never escape him; nor, it
seems, does she want to."

Burton has continued to epitomize the spirit of McQueen,
but her ideas have become more her own. For example, an
aesthetic riff on a beekeeper, complete with modernist veils, for
S/S 2013, was something bold and new.

While still focusing on McQueen's signature Victorian
and Edwardian shapes, her own designs have become more
romantic, noticeably since S/S 2016, a beautifully light and
feminine collection inspired by the seventeenth-century
Huguenot silk weavers of Spitalfields. McQueen would have

approved of the reference, as he was proud of being descended from these immigrants himself. And Burton's use of the show to make a statement about today's migrant crisis is just the sort of thing he would have done.

If anything, Burton has made McQueen's clothes more accessible and more wearable. She is obsessed with the idea of how women feel in their clothes, and how they express their individuality through fashion. And echoing McQueen, who liked to say he designed for women who wanted to be warriors, she even went so far as to call her designs for A/W 2018 "a soft armour for women".

Ironically, Burton's gentler attitude could be likened to that of Hubert de Givenchy, the legendary French couturier whom McQueen memorably dismissed as "irrelevant" when he briefly took up the helm at his fashion house in 1996. Both Burton and Givenchy recognized the importance of how the clothes a woman wore changed how she felt and acted.

As Burton explained to *Vogue* in 2017: "For me it's not just about a show or a review, it's about dressing women and how a piece makes them feel. As soon as you put a McQueen jacket on, you stand differently because it has a waist and it has a shoulder and it makes you feel empowered. It's great if you can do that for women."

This attitude has won Burton many new fans, including a host of celebrity clients. In 2011, when she was still a relatively unknown designer, Burton hit the headlines when she was commissioned to create an exquisite wedding gown for the now Princess of Wales, then Kate Middleton. The fashion house was chosen, the Palace confirmed at the time, "for the beauty of its craftsmanship and its respect for traditional workmanship and the technical construction of clothing".

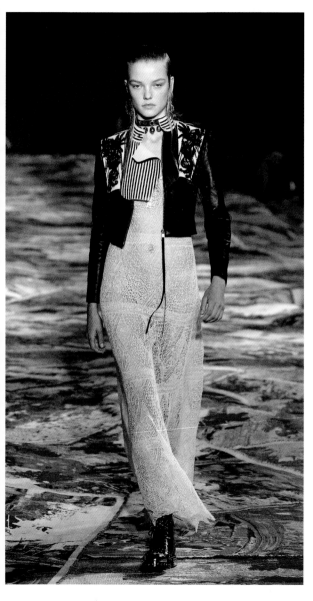

LEFT Sarah Burton has continued to demand the highest level of tailoring, equal to McQueen's Savile Row expertise. This black riff on a tuxedo has a pleated taffeta skirt detail, slashed with open lacework and metal embellishment.

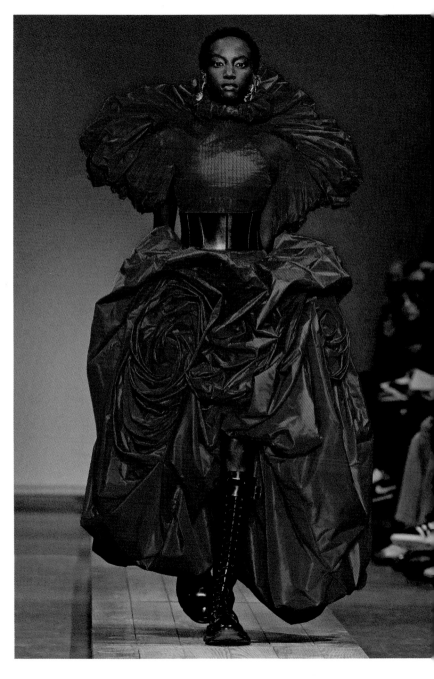

OPPOSITE This scarlet Elizabethan-inspired silk taffeta dress from A/W 2019 shows Burton is just as masterful at couture as McQueen himself. The voluminous silhouette features pleated sleeves that soar to an extended ruff over the shoulders and around the neck, and the skirt is pleated to resemble roses. The wide black leather belt and laced boots give it an edge of punk that would have won McQueen's approval.

Sarah Burton imbues her designs with such elegance that she continues to attract celebrities renowned for their style, including Michelle Obama, Liv Tyler and Sarah Jessica Parker.

Burton was obviously deeply affected by the global pandemic and, at the height of it, expressed similar feelings regarding her design ethos to that of McQueen just before he died. The show notes for her S/S 2021 collection read: "Shape, silhouette, and volume, the beauty of the bare bones of clothing stripped back to its essence – a world charged with emotion and human connection."

In a post-pandemic world, she is looking to nature more than ever, using recycled and sustainable fabrics. For her A/W 2022 collection, she cited as inspiration mycelium, the delicate plant filaments of fungi which are now used as an alternative to leather. Mushroom motifs abounded on beautiful clothes and the catwalk was scattered with wood chips. The show notes talked of nature being "a community that is far, far older than we are".

Alexander McQueen would have been proud.

THE SARABANDE FOUNDATION

McQueen left one more legacy to the world of fashion and the creative arts – the Sarabande Foundation. The foundation was given charitable status in 2010, and on his death, McQueen left the vast majority of his estate to the support of its work.

Sarabande, named after his S/S 2007 show, was established by McQueen in 2006 with the intention to "support the most creatively fearless minds of the future".

In the wake of his tragic suicide, a group of his closest friends and collaborators looked for a way to honour his memory.

RIGHT This muted pink tailored coat dress is a play on a classic trench reminiscent of McQueen's Givenchy years. The luxurious intricately quilted silk is offset by a black leather belt cinched at the waist, and the asymmetric hem is raised at the front.

OPPOSITE This leather patchwork dress in striking black, red and purple from the A/W 2020 collection is a combination of a classic little black dress, cinched at the waist, with a clever layered drape over one shoulder.

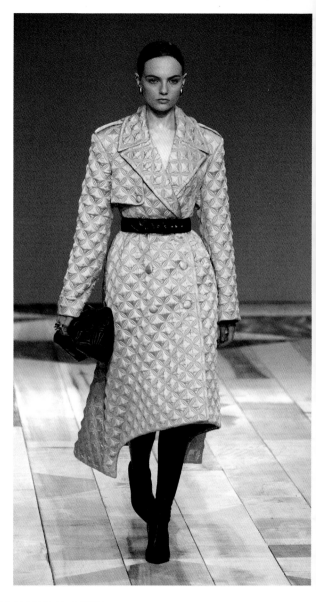

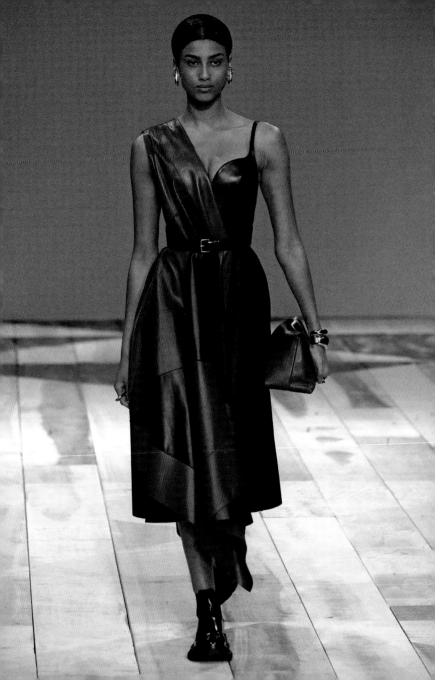

Among others, photographer Nick Knight, jeweller Shaun Leane, artist Sam Taylor-Johnson and model Naomi Campbell worked to continue what McQueen had started.

In 2015, the foundation opened a community-minded space, including subsidized studios, in an East End converted warehouse where McQueen would most certainly have felt at home. It has also funded a number of educational scholarships. By 2020 the foundation had helped 100 up-and-coming creatives across a variety of disciplines, with successful alumni including menswear designer Craig Green. Their outreach programme of events and workshops has helped thousands more.

As Trino Verkade, long-time friend and business associate of McQueen and the founding trustee of Sarabande, explained to *Something Curated* in 2017: "He was a great supporter of young creatives and very passionate about giving people the opportunity to study if that's what they wanted to do, and not be held back by financial constraints."

The foundation continues to help youngsters achieve their dreams in the name of Lee Alexander McQueen.

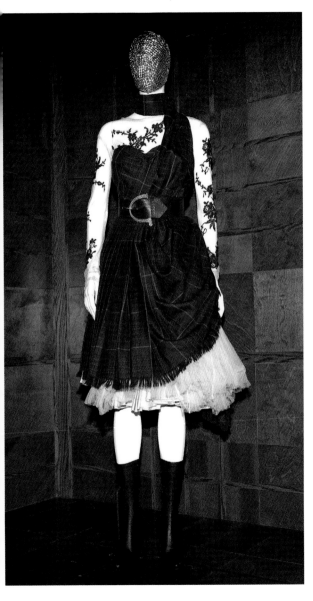

LEFT McQueen's legacy cannot be underestimated and in 2011 the Metropolitan Museum of Art held a stunning retrospective dedicated to his genius which was shown again with additional exhibits at the Victoria and Albert Museum in 2015. One of the exhibits, perfectly staged to highlight McQueen's gothic aesthetic, was this dress from his A/W 2006 collection Widows of Culloden, which was inspired by the traditional kilts of McQueen's Scottish ancestors. It is made in the MacQueen clan tartan and worn over a nude silk net top with appliquéd black flowers and a cream tulle underskirt.

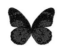

INDEX

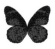

CREDITS

The publishers would like to thank the following sources for their kind permission to reproduce the pictures in this book.

Alamy: Abaca Press 18, 117; /Artefact 24; / Chronicle: 12; /DPA Picture Alliance 150; / Nathan King 119; /Reuters 130; /Trinity Mirror/Mirrorpix 79

Photograph by Nikki Brickett, © RR Auction: 34, 38, 39, 43, 44, 46, 48, 69, 122

Camera Press: Photography by Charlotte Macpherson, Camera Press 33; /Photograph by Anthea Simms, Camera Press 6, 40, 83, 85

Getty Images: Bassignac/BUU/Gamma-Rapho 91; /Benjamin Auger/Paris Match 52; /Dave Benett 125, 138; /Randy Brooke/ WireImage 96; /Stephane Cardinale/Corbis 92-93, 94; /Alexis Duclos/Gamma-Rapho 42; /Michel Dufour/WireImage 97; /Steve Eichner/WWD/Penske Media 135; /Estrop 146, 149; /Matthew Fearn/AFP 9; /Giovanni Giannoni/WWD/Penske Media 100, 101; / Francois Guillot/AFP 102, 105, 106, 109, 110, 113, 126; /Dave Hogan 133; /Chris Jackson 145; /Stephen Lovekin 142; /Guy Marineau/Condé Nast 80; /Mike Marsland/

WireImage 71; /Catherine McGann 31, 139; / Desiree Navarro/FilmMagic 132; /Print Collector 15; /Stephan Schraps 136; /Daniel Simon/Gamma-Rapho 55; /Kristy Sparow 152, 153; /Pierre Verdy/AFP 58, 59, 62; / Victor Virgile/Gamma-Rapho 76, 77, 114, 129; /Paul Zimmerman 155

Private Collection: 23

Copyright Ruti Danan: 36

From the Alexander McQueen Archive of Ruti Danan Sale, RR Auction, February 22, 2020: 28, 99

Shutterstock: 66, 118; /Michael Euler/AP 56; /Alex Lentati/Evening Standard 75; /Cavan Pawson/Evening Standard 82; /Andy Rain/ EPA 20-21; /Ken Towner/Evening Standard 63; /Paul Vicente/EPA 72-73; /Steve Wood: 47, 61, 86, 88

Every effort has been made to acknowledge correctly and contact the source and/or copyright holder of each picture. Welbeck Publishing apologizes for any unintentional errors or omissions, which will be corrected in future editions of this book.